A Pictorial
Celebration By
The Winners of the
Parade-Kodak
National Photo
Contest

Love

*Introduction
By Walter Anderson*

CONTINUUM • NEW YORK

"The Whole World Is Before Us!" Angelica Gutierrez, 6, and sister, Artemiza, 8, at "Hole-in-the-Rock," near the Phoenix Zoo. Photo by Jamie Strelow of San Diego, Calif.

1994

The Continuum Publishing Company
370 Lexington Avenue
New York, N.Y. 10017

Copyright ©1994 by Parade Publications, Inc.

Design by Ira Yoffe

Printed in Spain

Library of Congress Cataloging-in-Publication Data
Love: a pictorial celebration
/by the winners of the Parade-Kodak National Photo Contest:
introduction by Walter Anderson.
p. cm.
ISBN 0-8264-0668-8
1. Photography, Artistic.
2. Love–Pictorial works.
3. Photography of families.
4. Photography of animals.
I. Anderson, Walter, 1944–.
II. Eastman Kodak Company.
III. Parade (New York, N.Y.)
TR654.L68 1994

779′ .26′ 0973–dc20

94-11332
CIP

*Formula for Love: Retired chemistry
professor Solomon Marmor, 67, and wife,
Lynne, 69, also a retired teacher, have been
married since 1954. Photo by their son,
Jonathan P. Marmor, a student at the
University of Washington in Seattle.*

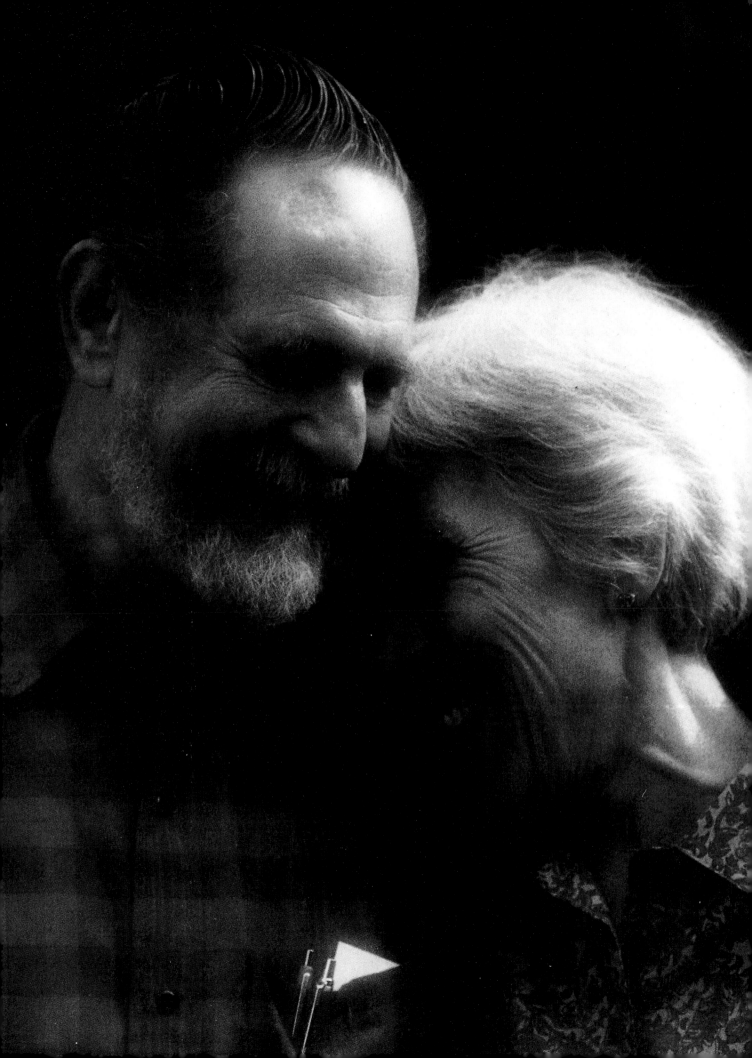

Introduction

*L*ove may or not make the world go round, as the old saying puts it, but it certainly makes it a more stimulating and enchanting place in which to live. If you have any doubt about that, I invite you to turn the pages of this beautiful book, made up of the pictures that won top prizes in the seventh Annual PARADE-Kodak National Photo Contest.

When we announced that our theme would be: What Does Love Mean to You? we expected a wide range of pictorial answers, for while poets since the beginning of time have celebrated romantic love, we all know there are many other kinds–love of parents, love of children, love of pets, love of country, love of freedom. So variety was inevitable, especially considering that PARADE Magazine, which I have the honor to edit, has 73 million readers in 50 states and this year's contest entries numbered an all-time high of well over 200,000 entries.

Nevertheless, our distinguished judges–Eddie Adams, the Pulitzer Prize-winning photographer; Dr. Joyce Brothers, the psychologist; Marian Wright Edelman, president of the Children's Defense Fund; Leeza Gibbons, co-host of the weekend edition of TV's "Entertainment Tonight" and "John and Leeza" with John Tesh; and Casey Kasem, the radio personality–all agreed that the breadth of this year's entries was extraordinary. You'll find their comments elsewhere in this book.

I, too, deal with photographs as part of my regular duties at PARADE, and while I cannot claim the expertise of our judges, I feel I know a good picture–especially a picture that tells a story well–when I see one. And there are many such in this book. While this contest is open to pros as well as to amateurs, it is the latter who predominate. Indeed, many of the pictures they submit are what we call "family pictures"–photos of loved ones or friends or neighbors as they go about their normal lives and daily activities. I never cease to be amazed by the care, creativity and technical mastery that go into these photos, as well as by the care and affection the photographers bring to their subject matter.

So there is a freshness, vitality and personal quality about these pictures that in my opinion set this book apart from other photo collections. Love has many faces, and virtually all of them are here. And they add up to a memorable image of the America that we all cherish.

Walter Anderson

Bridal Landscape: Margey Whalen of Mar Vista, Calif., captures an intimate moment at the wedding of Celeste Whalen and Brian McIntyre.

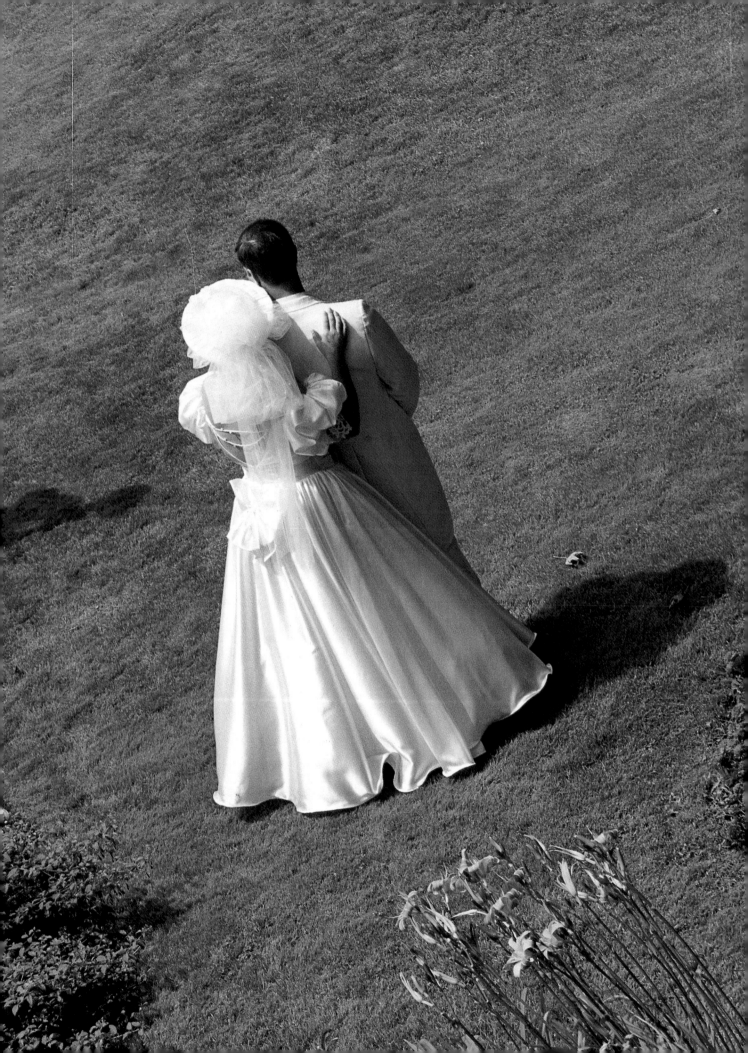

"Who Loves You?" Veronica Snock and her son, James, 3, of Cuyahoga Falls, Ohio, answer that question on a fountain rim in a park near Three Rivers Stadium in Pittsburgh. Photo by James' dad, Keith J. Snock of Cuyahoga Falls.

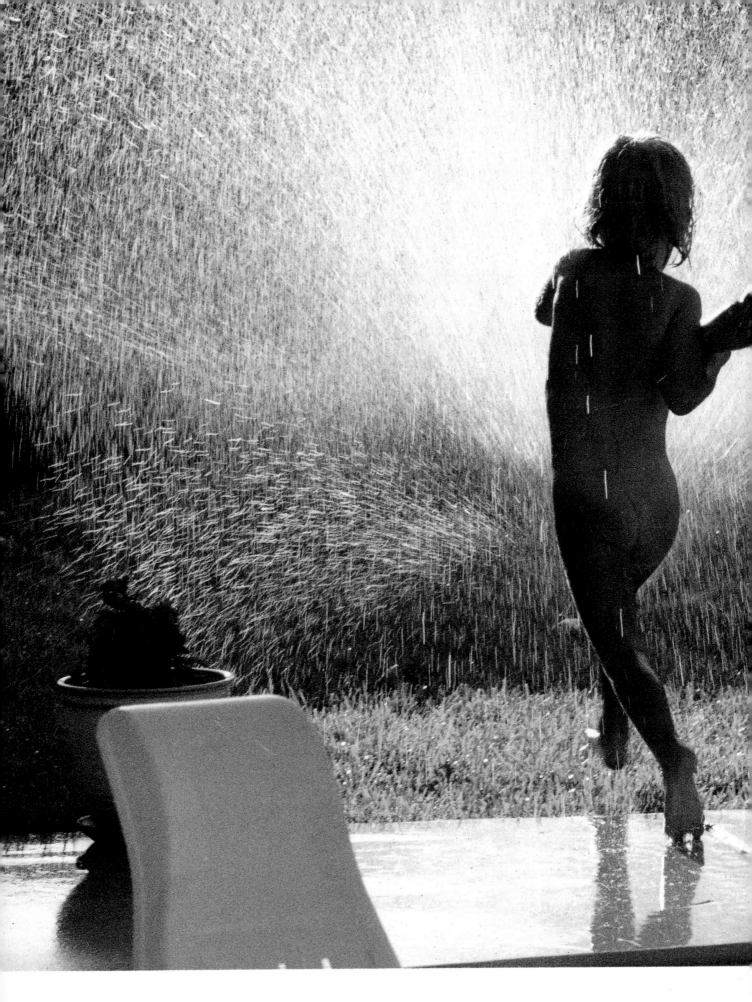

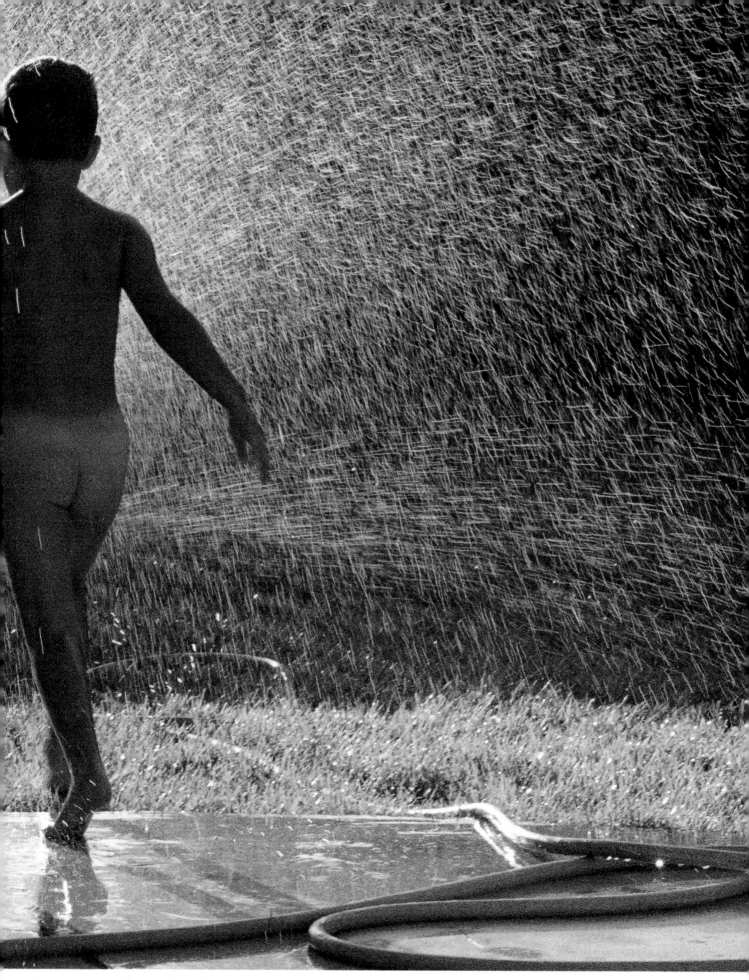

Sibling Revelry: Ashley Freyer, 3, and Jason Freyer, 5, leap like water sprites in their yard in Windsor, Calif. Photo by their mother, Sue Freyer of Windsor.

"Love is merely a madness..."
–William Shakespeare

࿓

"When love and skill work together, expect a masterpiece."
–John Ruskin

࿓

"Love and the gentle heart are but a single thing."
–Dante Alighieri

࿓

*"Come live
with me, and be my love
And we will
Some new pleasures prove,
Of golden sands
and crystal brooks,
With silken lines,
and silver hooks."*
–John Donne

Swing With Mom:
Year-old Tommy McCreary
with his mother, Alison,
of Summit, N.J. Photo by
Caroline McBride
of Locust Valley, N.Y.

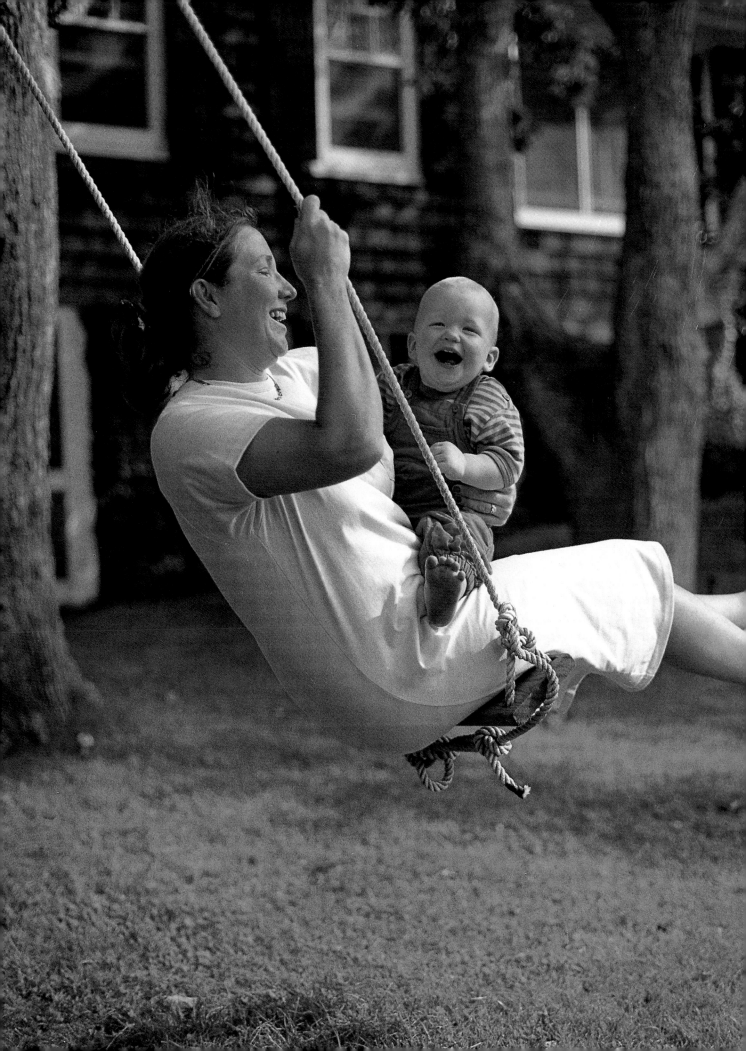

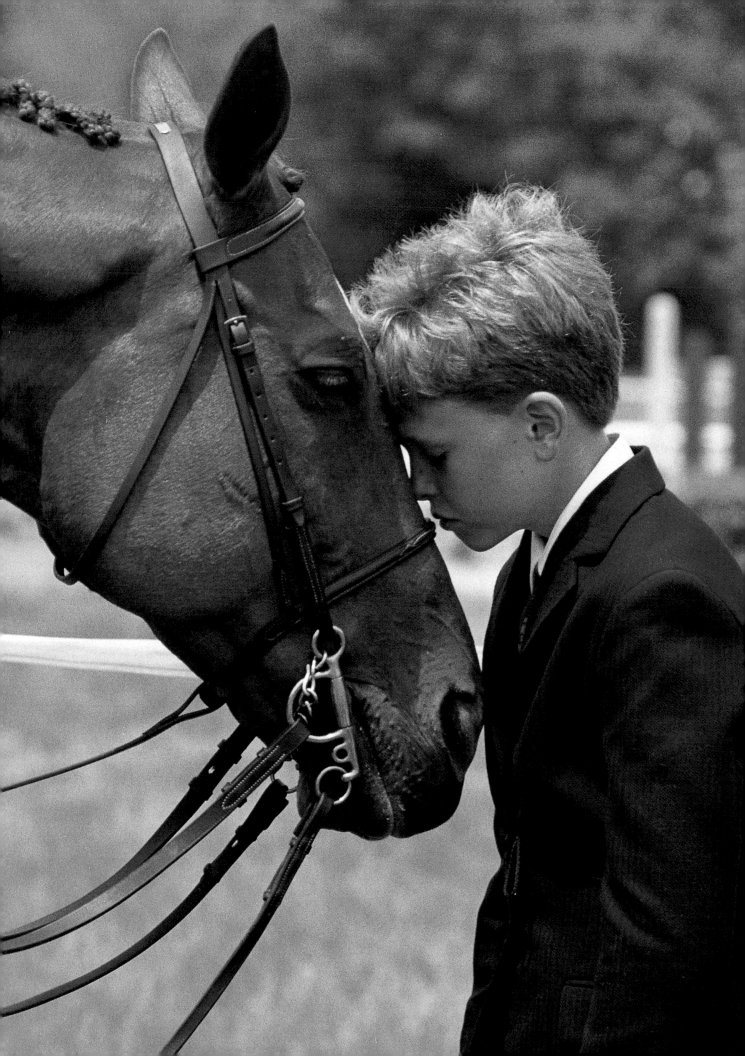

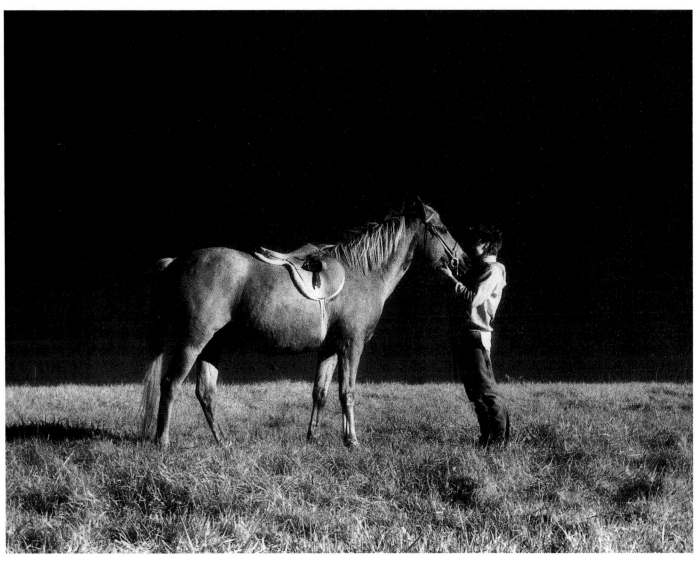

Special Relationship: Brandy Knoebel and her horse, Tara. Photo by her husband, Eric Knoebel of Joppa, Md.

Next Time: Cory Hardy, 12, of Shrewsbury, Mass., and his horse, Make My Day, in between competitions at a horse show. The pair earned a second-place ribbon that day. Photo by Deara B. Bartlett of Beverly, Mass.

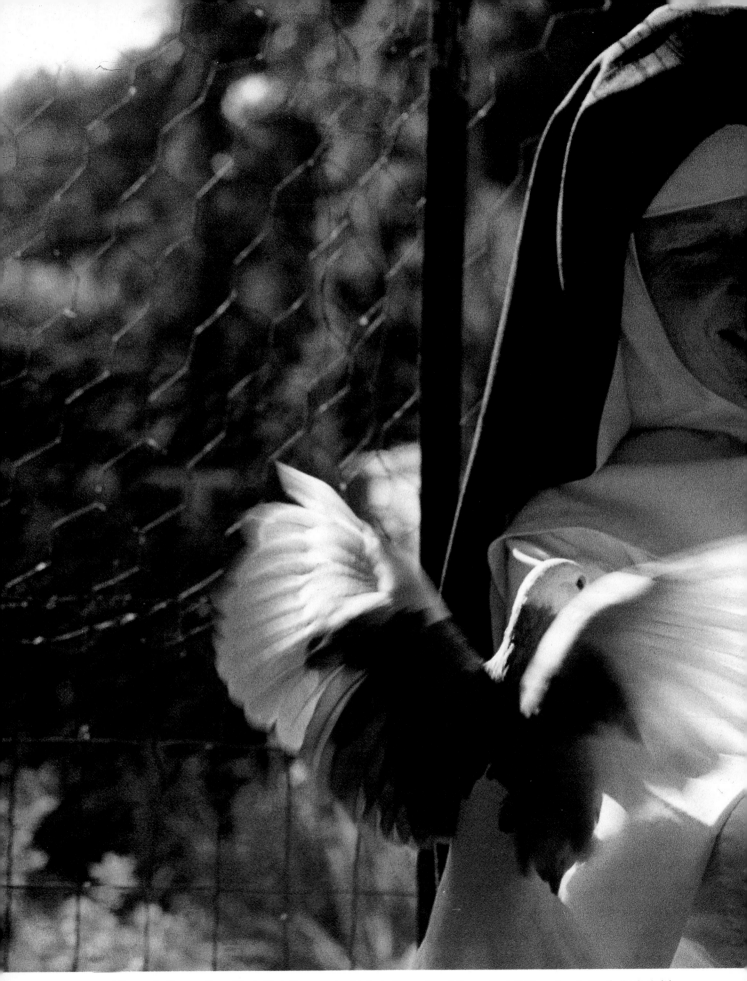

A Wing and a Prayer: Sister Maria Christine, with her birds, in the garden of Corpus Christi Monastery in Menlo Park, Calif.
Photo by Sister Mary of the Holy Spirit.

16

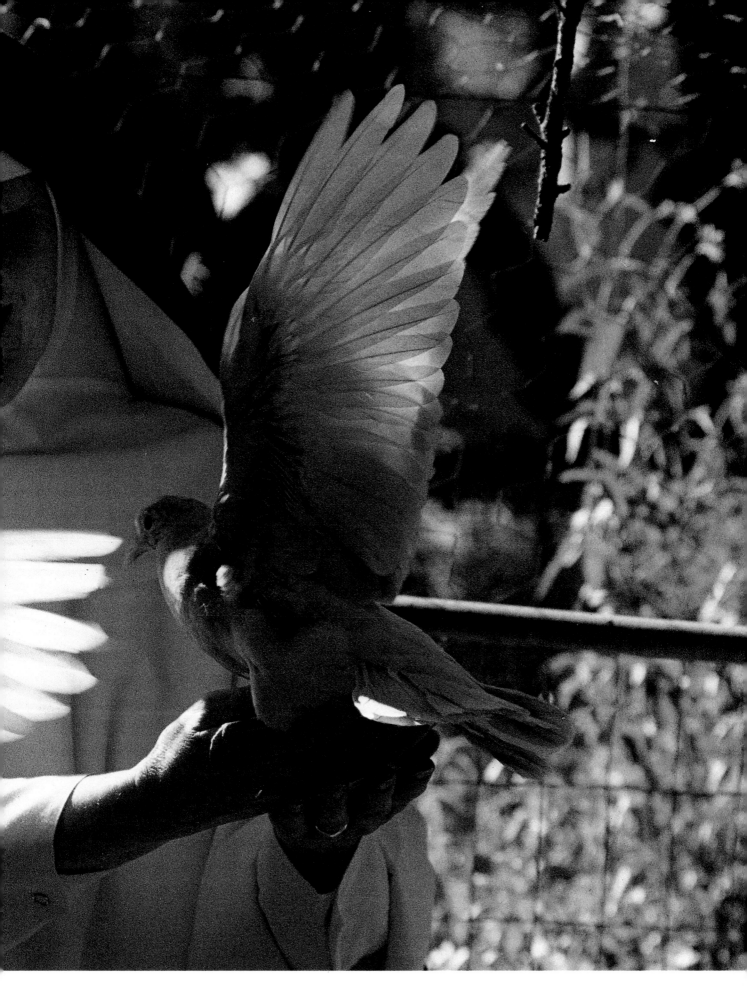

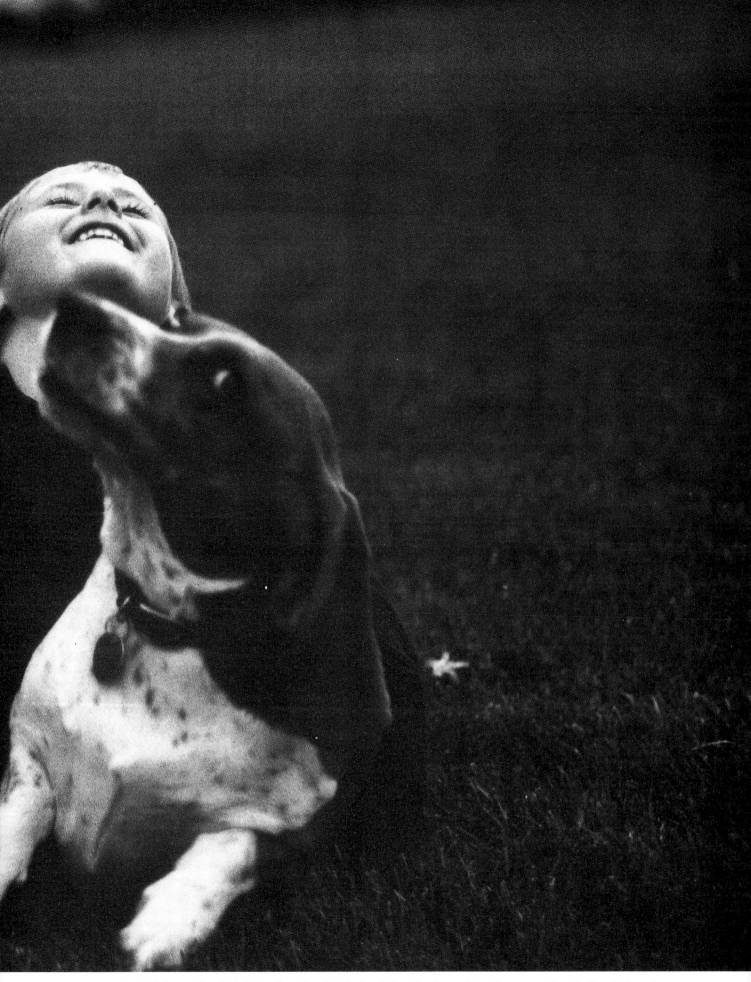

"It Doesn't Get Much Better Than This." Douglas Adam Smith, 6, and Troubles share a blissful moment. Photo by Douglas' mother, JoAnn Marie Smith of Jefferson City, Mo.

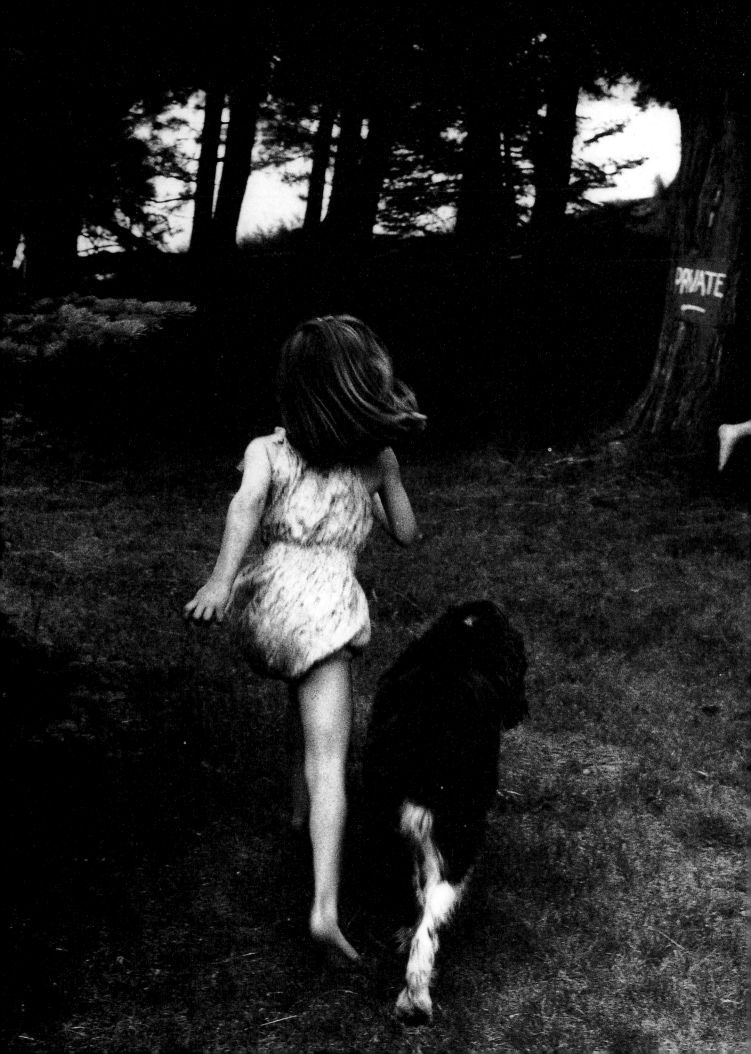

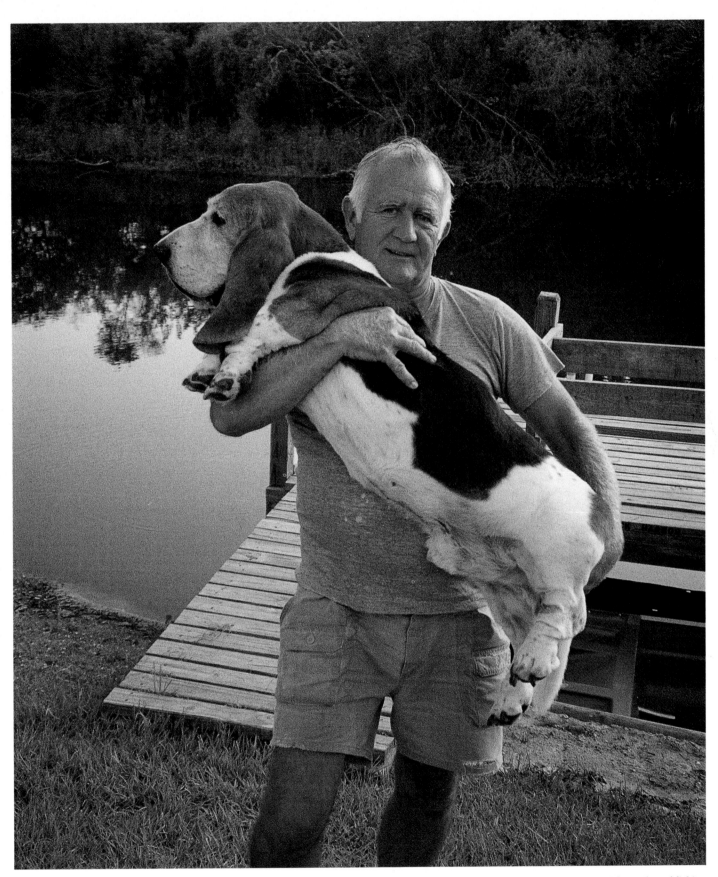

Old Companion: After a day of fishing, Donald Kincart carries Rippley, 12, up the hill and home. Photo by Donald's wife, Alvera Kincart of Englewood, Fla.

Wait for Me! Christine Hawn, 5, and Goldie pursue her brother, David, 7, near Higgins Lake, Mich. Photo by Elizabeth Kushman of Vienna, Va.

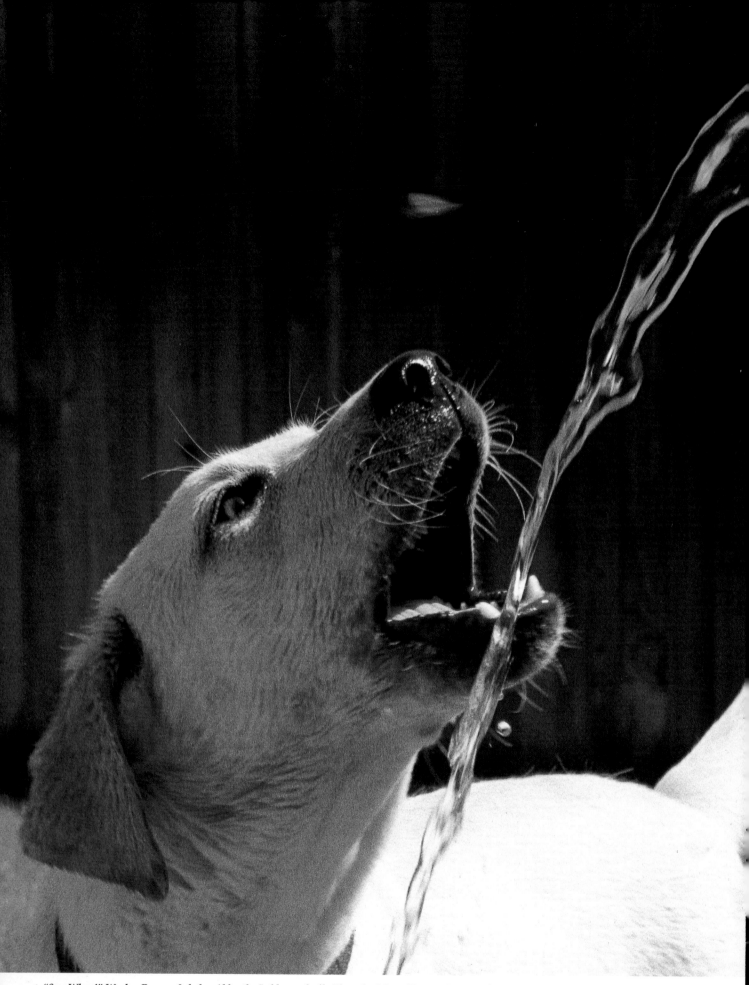

"Say When!" Wesley Reeves, 2, helps Abby the Labby cool off. Photo by Mary Clemow Reeves of Colorado Springs, Colo.

22

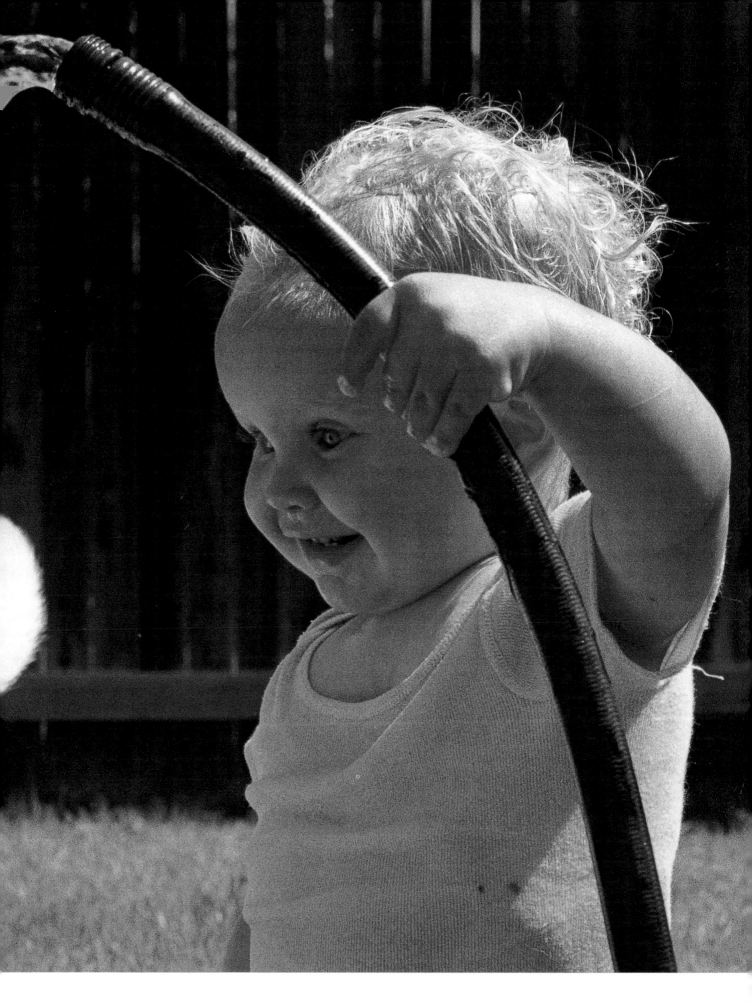

Heart to Heart: Jesse Steindler communes with his best friend in Carbondale, Colo. Photo by Andrea Roth of Boulder, Colo.

Peter Owen, 5, who was born in Korea, "just loves his dog, Lacey, and we love Peter," says his mother, Elaine Owen of Houston, Tex., who took the picture.

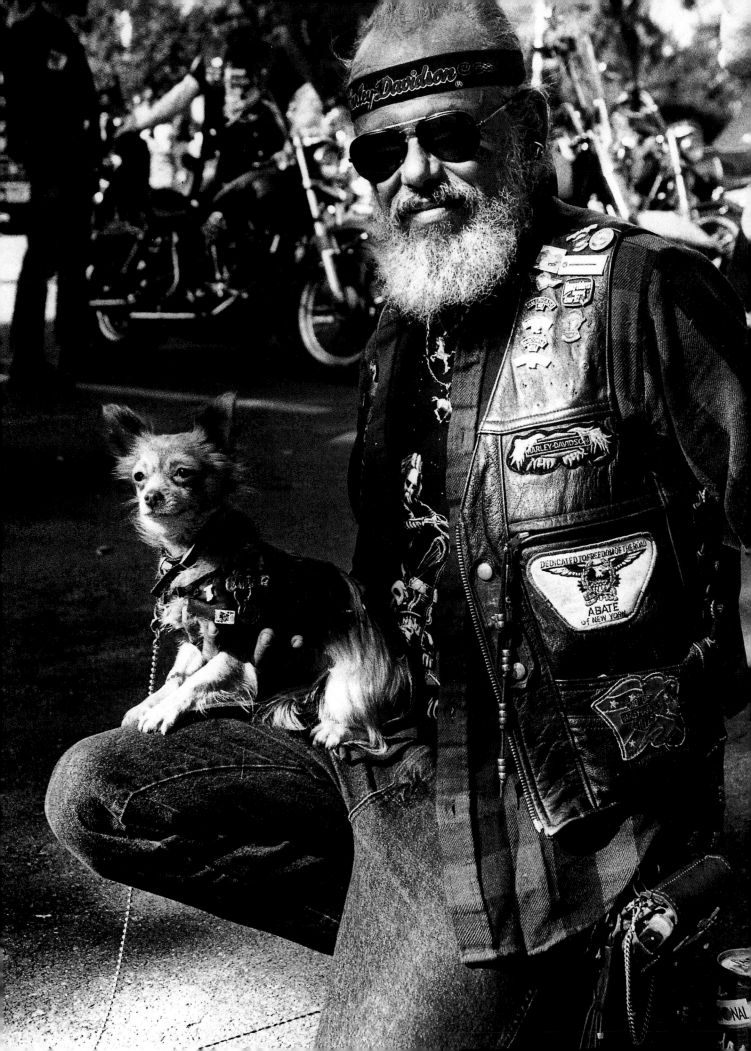

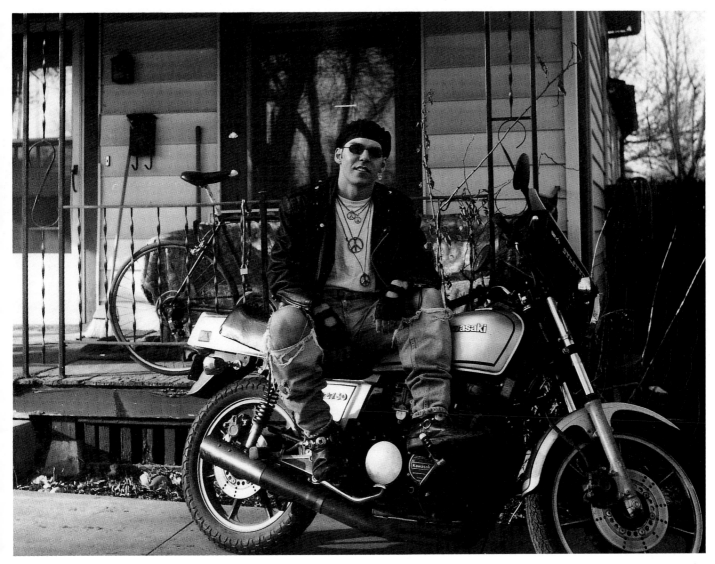

Peace: Jeff Erickson on his Kawasaki in Lincoln, Neb. Photo by his brother, Aaron Erickson of Lincoln.

Love Drive: Bobby Shoemaker is a member of a motorcycle club that collects Christmas toys for underprivileged children. Photo by Kathleen Vernier of Chatham, N.Y.

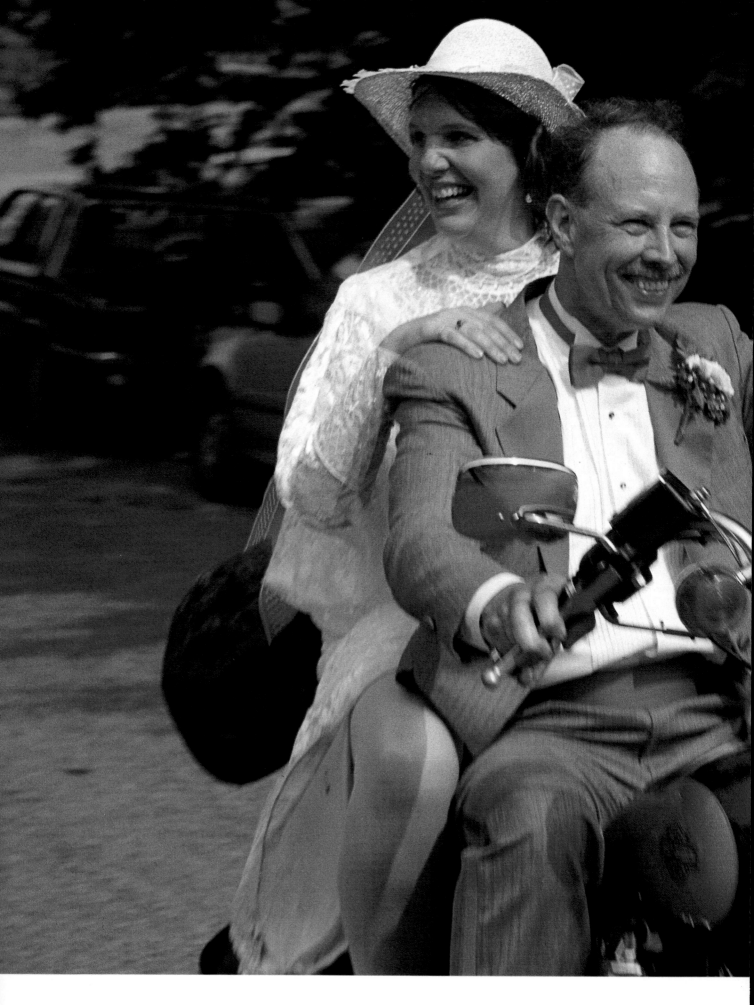

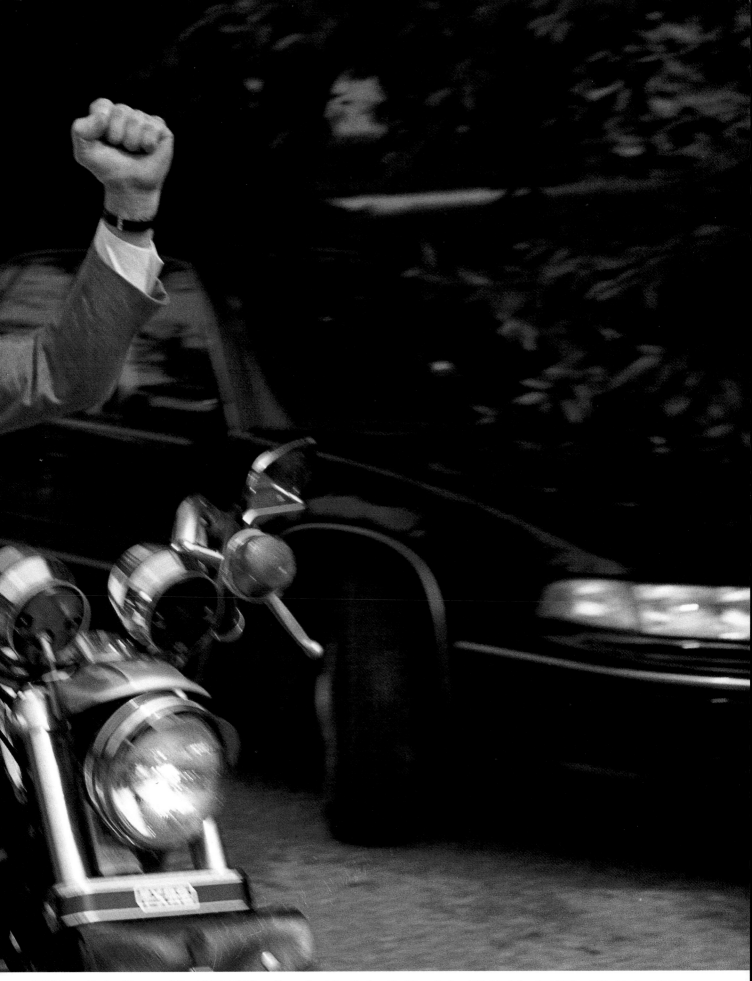

Wild Ones: Rosina Mason and Daniel Whitfield rev it up after tying the knot in Silver Spring, Md. Photo by Carl Sittle of Washington, D.C.

Country Wedding: The table decor was Mason jars with beans, wheat and ribbons; the guests did the two-step; and the newly married couple, Madeline and Bob Blohm, rode off in a surrey. Photo by their friend, Bonnie Poppe of Saginaw, Mich.

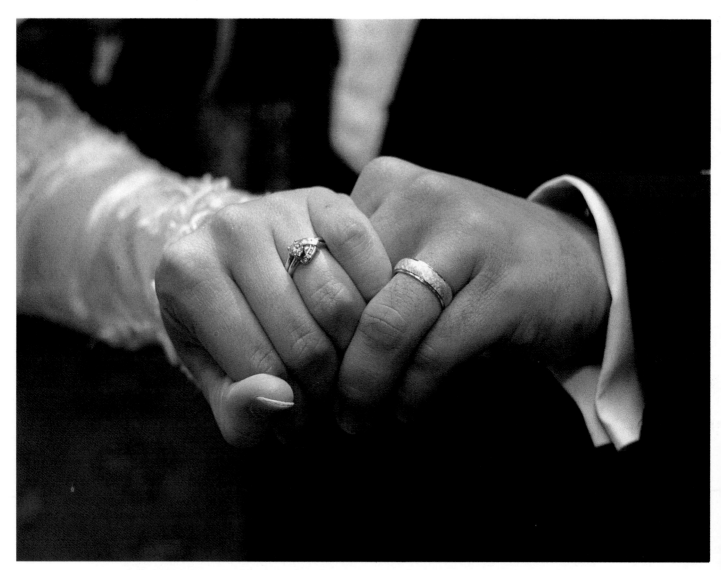

Linked: Jill Belcher of Redmond, Wash., took this photo of just-marrieds Kelly and Matthew Van Parys.

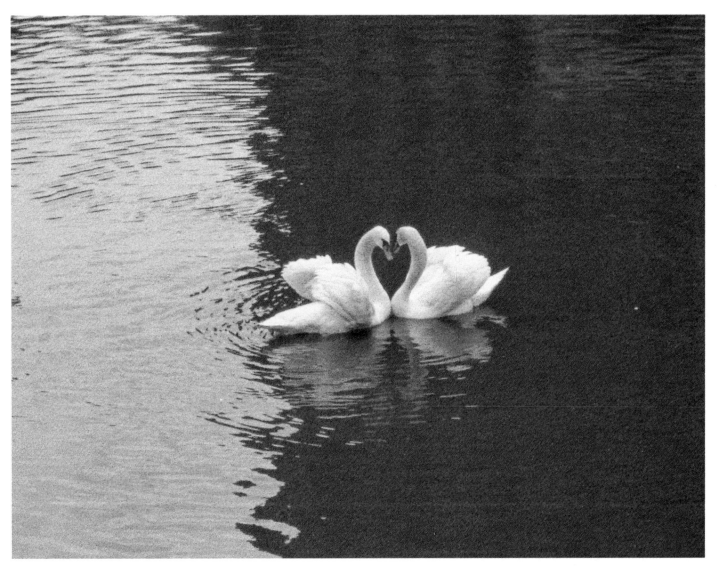

The Shape of Love: Peter Herscovitch of Chevy Chase, Md., captured the graceful pair near Tokyo's Imperial Palace.

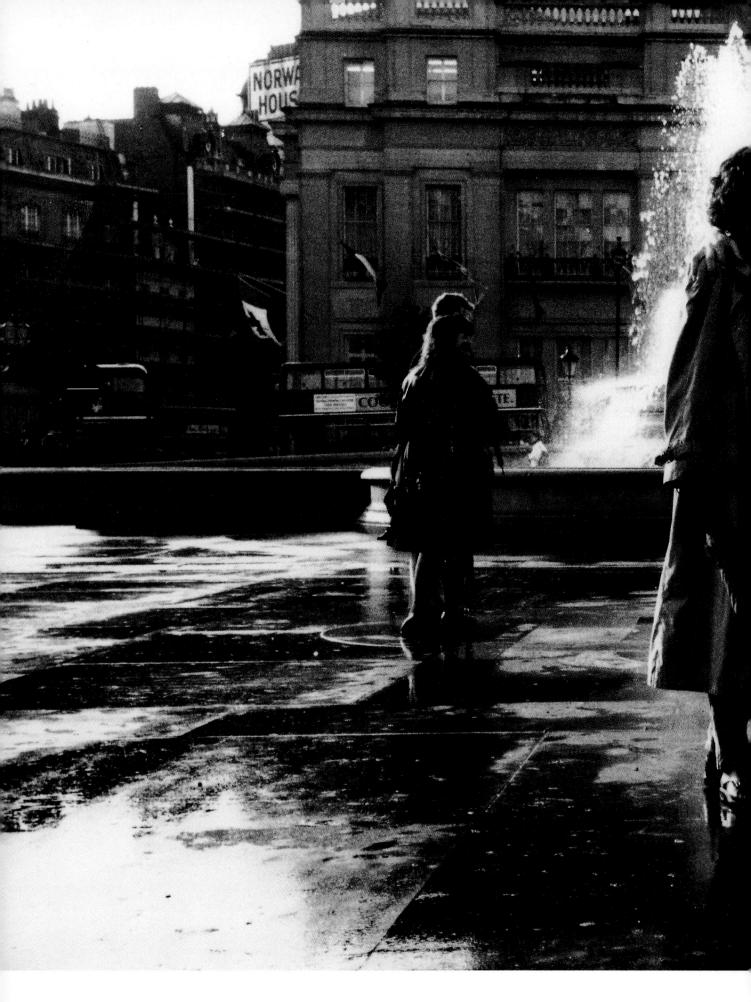

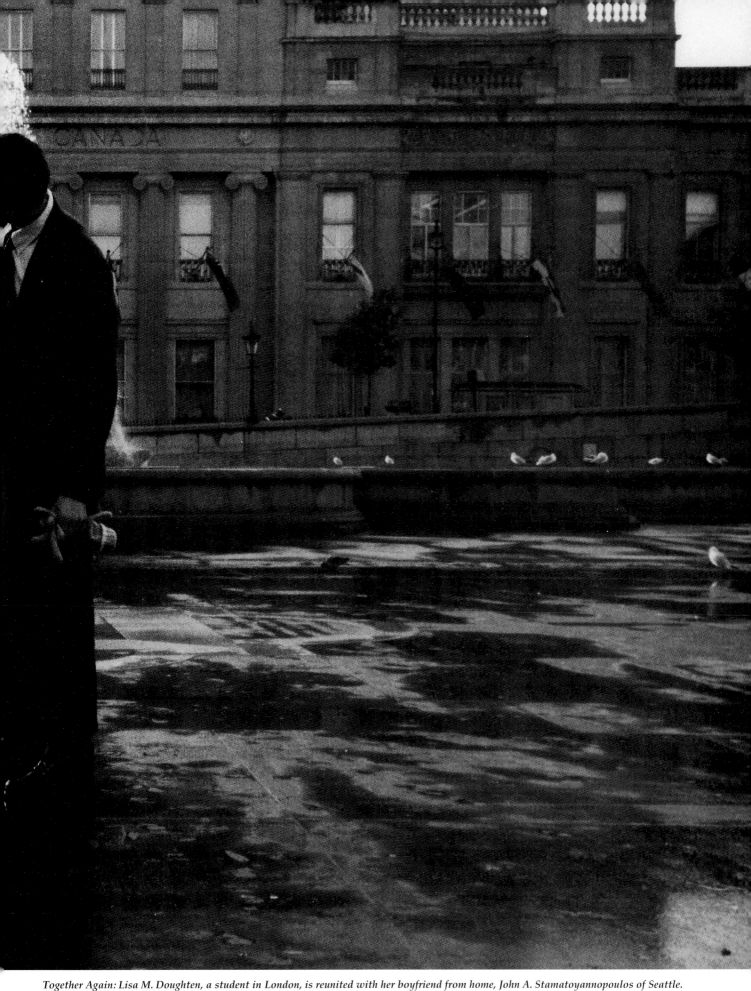

*Together Again: Lisa M. Doughten, a student in London, is reunited with her boyfriend from home, John A. Stamatoyannopoulos of Seattle.
He triggered the picture in Trafalgar Square using a remote.*

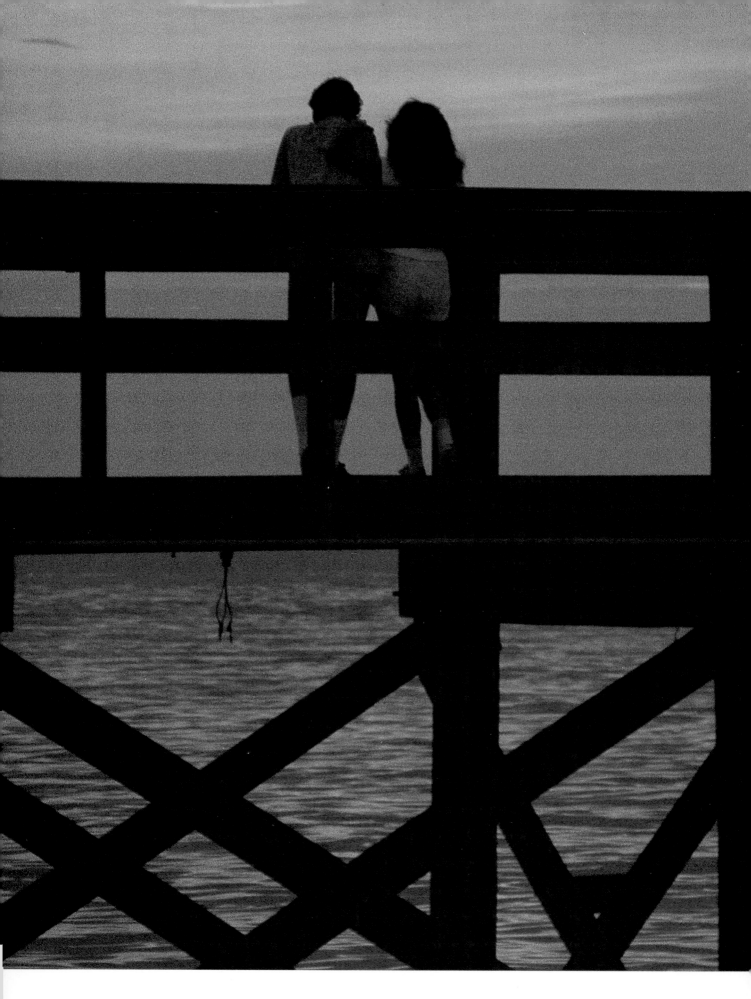

You and Me and the Sunset: John G. Prior of Gretna, La., was instantly affected by the mood of this New Orleans scene.

A Shared Passion: Karl and Carolyn Andersen of Lake Mills, Wis., are retired and involved in their local government and community. Photo by Robert Heussner of Lake Mills.

41

Forget-Me-Nots: Jeannette Caldwell of St. Louis with her sweetheart, Howard Horowitz of New York City.
Photo by Amanda Ruzycki of Newmarket, N.H.

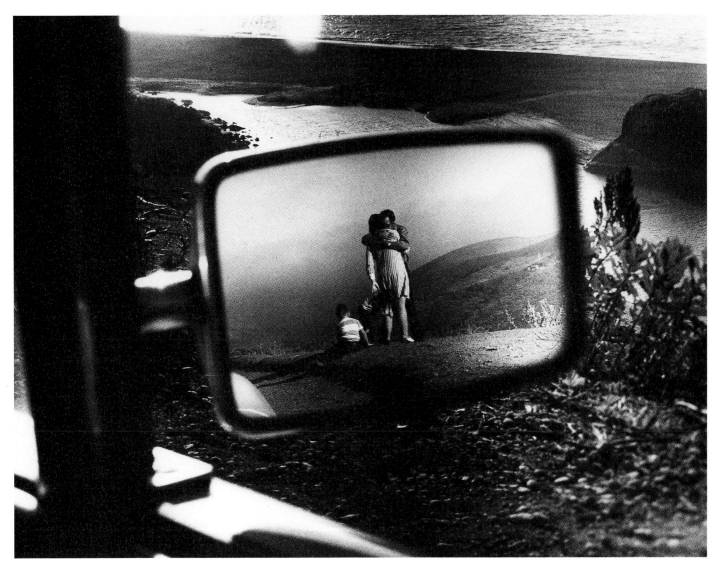

1973 Reflection: As a photography student, says J. Rodney Wyatt of San Diego, "I stopped near Santa Rosa, Calif., to watch the Russian River flow into the Pacific Ocean. Suddenly, in my side-view mirror, I saw this portrait of strangers in love."

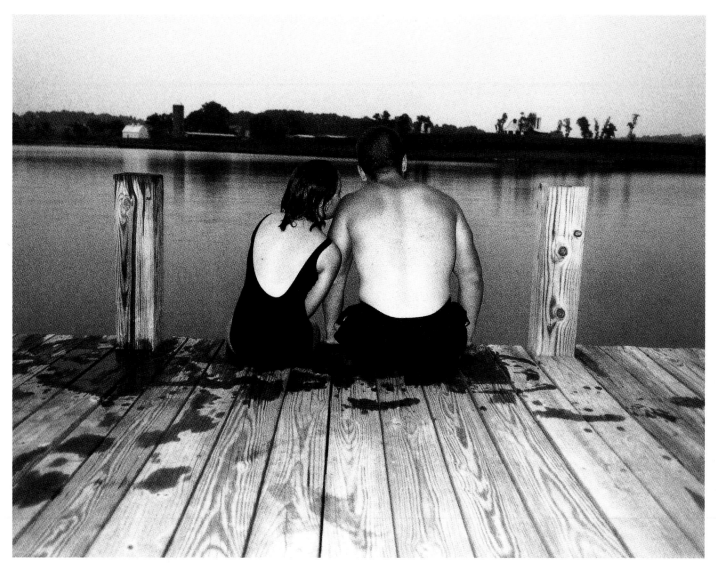

Sharing a Secret? Longtime friends Saundra Troy (l), 12, and Ben Sanford, 18, had been swimming all afternoon.
Photo by Linda M. Howes of Londonderry, N.H.

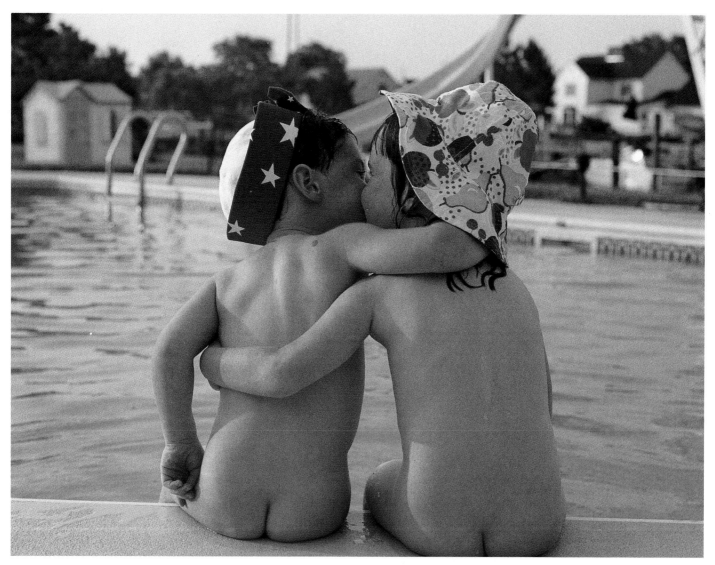

Cheek-to-Cheek: Lauren Hartman, 4, and brother Jordan, 2, get close at poolside.
Photo by their mother, Colleen Hartman of Poquoson, Va.

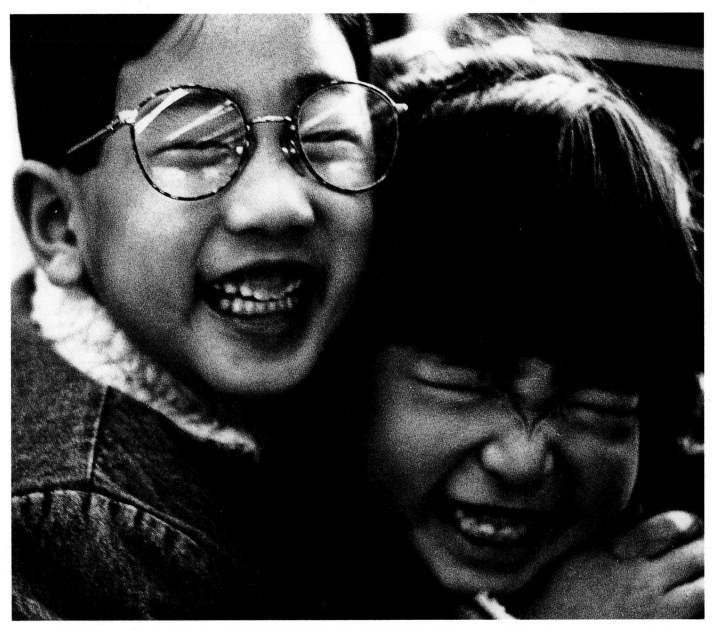

*A Big Hello: Cousins Justin Koyama, 4, of Bellevue, Wash., and Caitlin Kakigi, 6, of Kensington, Calif., are happy to see one another.
Photo by Jennifer Kakigi of Oakland, Calif.*

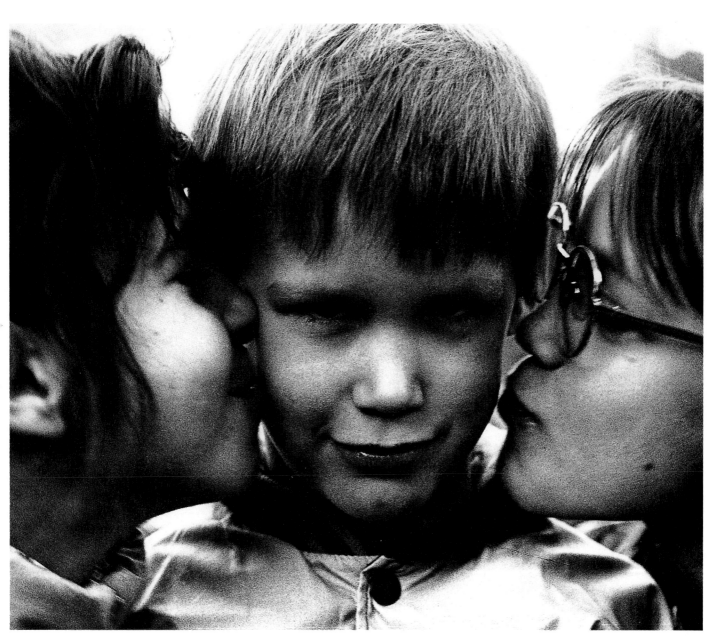

"Tell Me When It's Over." Bryant Magnien, 6, is about to be smooched by his sister, Michelle (r), 10, and Sara Burns, 9, a neighbor. Photo by Trisha Uttenreither of Catonsville, Md.

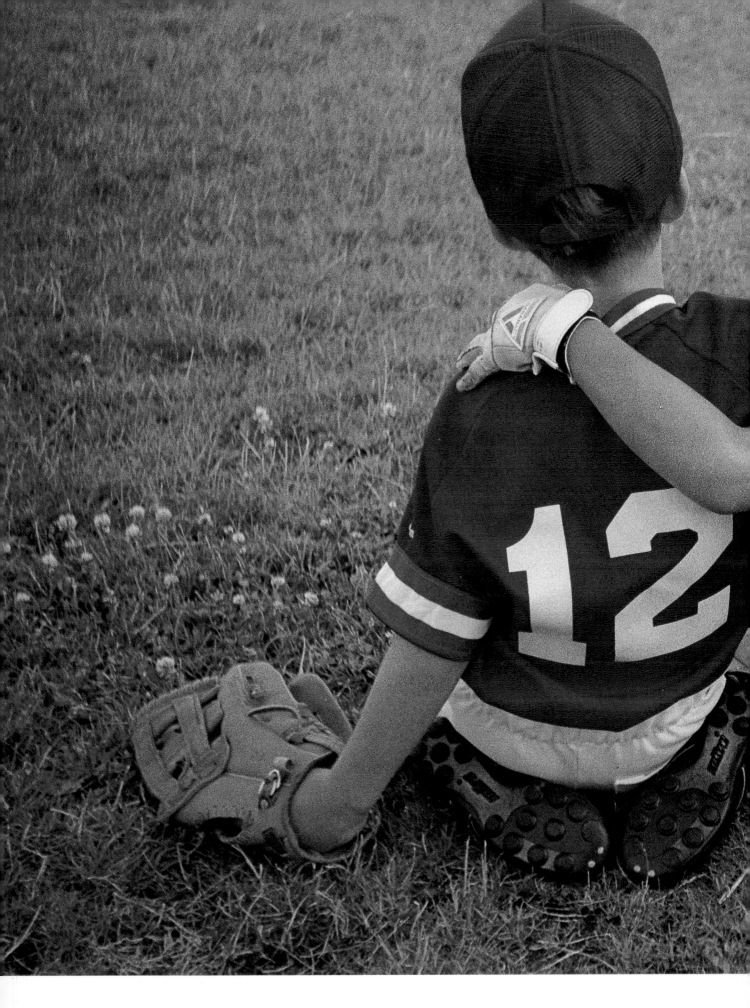

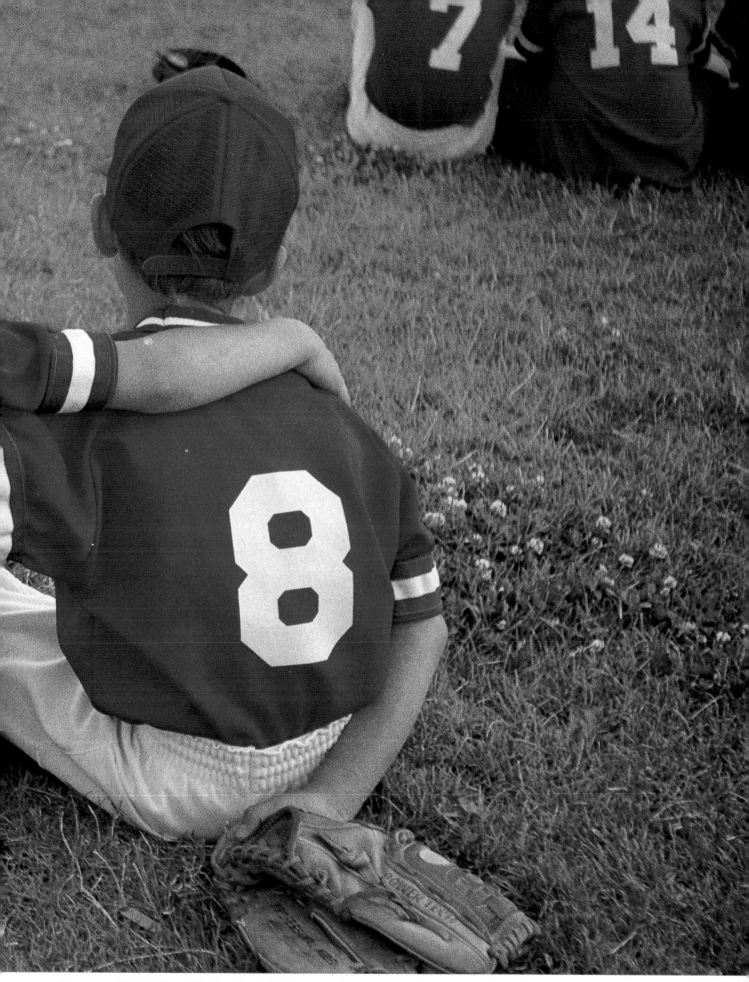

Teammates: T.J. List (l), and Matthew Lueck, both 7, await their turn at the plate during a peewee league summer baseball game.
Photo by Matthew's mom, Ann Lueck of Spokane, Wash.

"All you need is love!"
–The Beatles

❧

"Immature love says 'I love you because I need you.'
Mature love says, 'I need you because I love you.'"
–Erich Fromm

❧

"Love is unhappy when love is away."
–James Joyce

❧

"To fear love is to fear life."
–Bertrand Russell

Home Is Where the Heart Is:
Nicholas Turner, 5, and Britan Mills, 4,
share a kiss at home plate in Edmond,
Okla. Photo by Britan's mother,
Karen Mills of Shawnee, Okla.

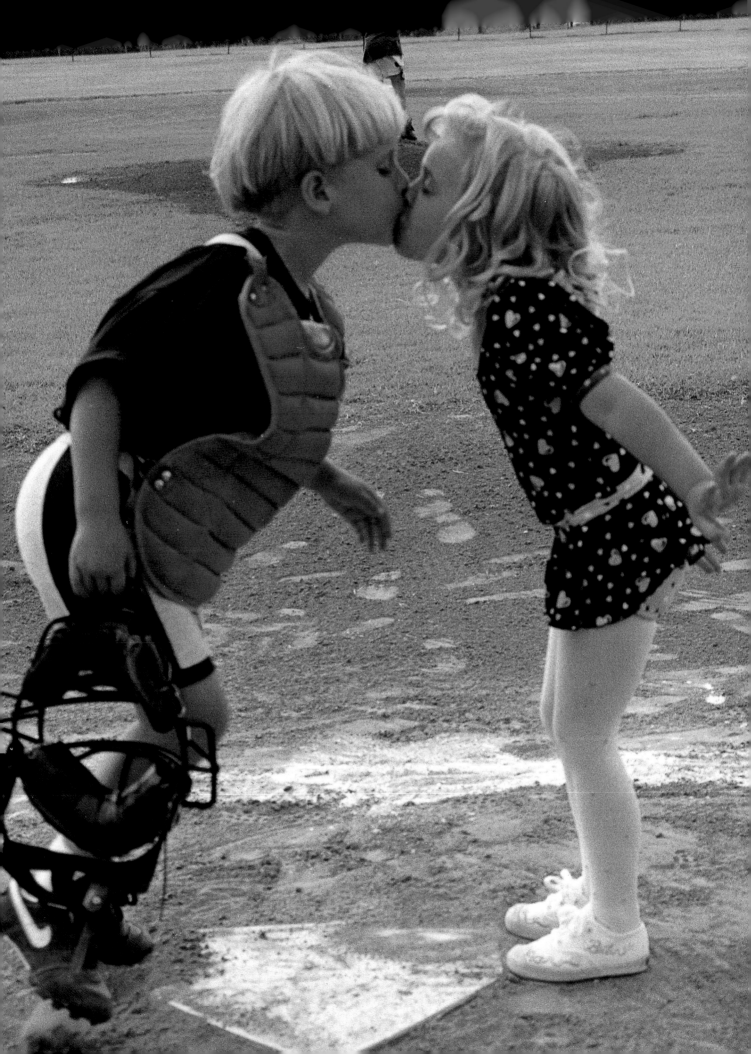

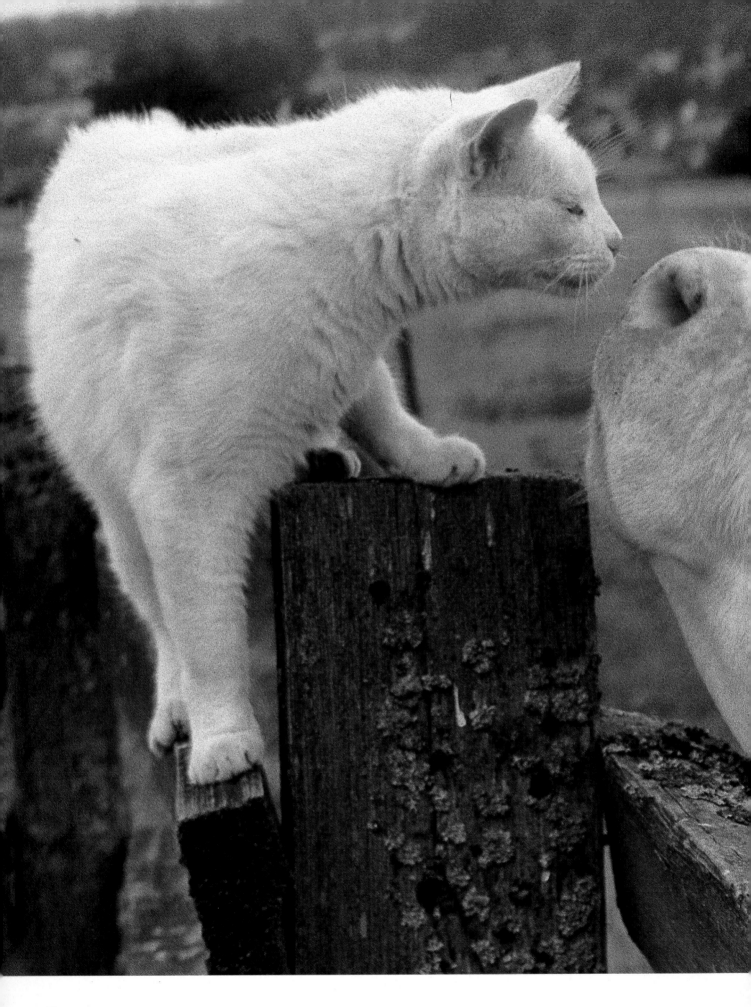

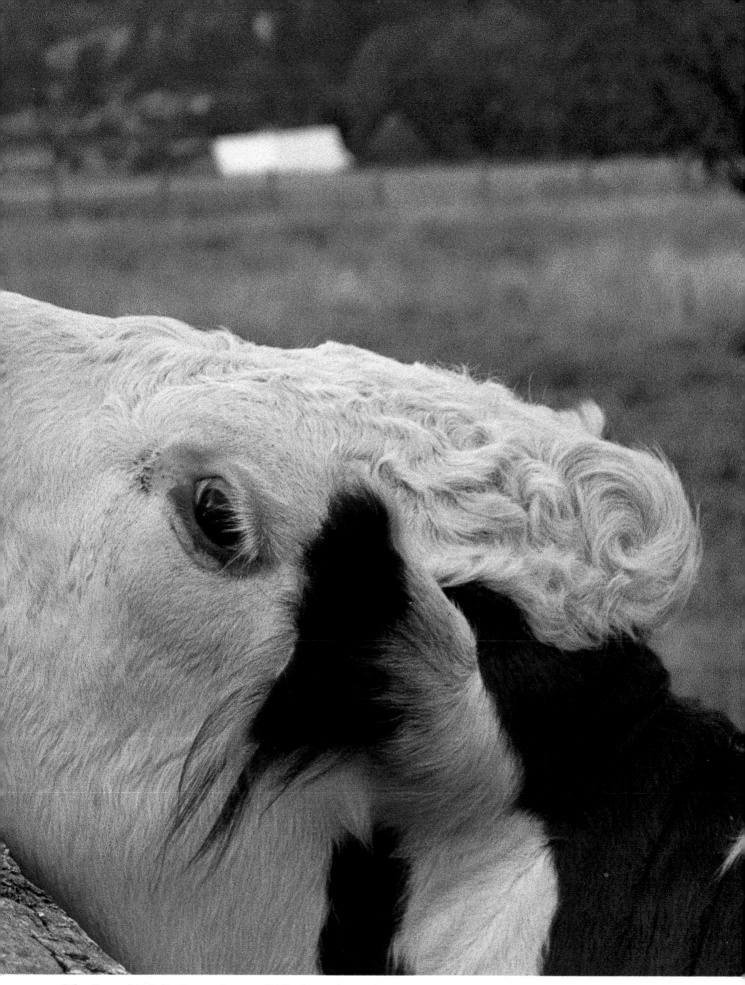

When Tommy Met Tulip: Tommy the cat and Tulip the cow have a close encounter. Photo by Wendy Goodwin of Pacific, Wash.

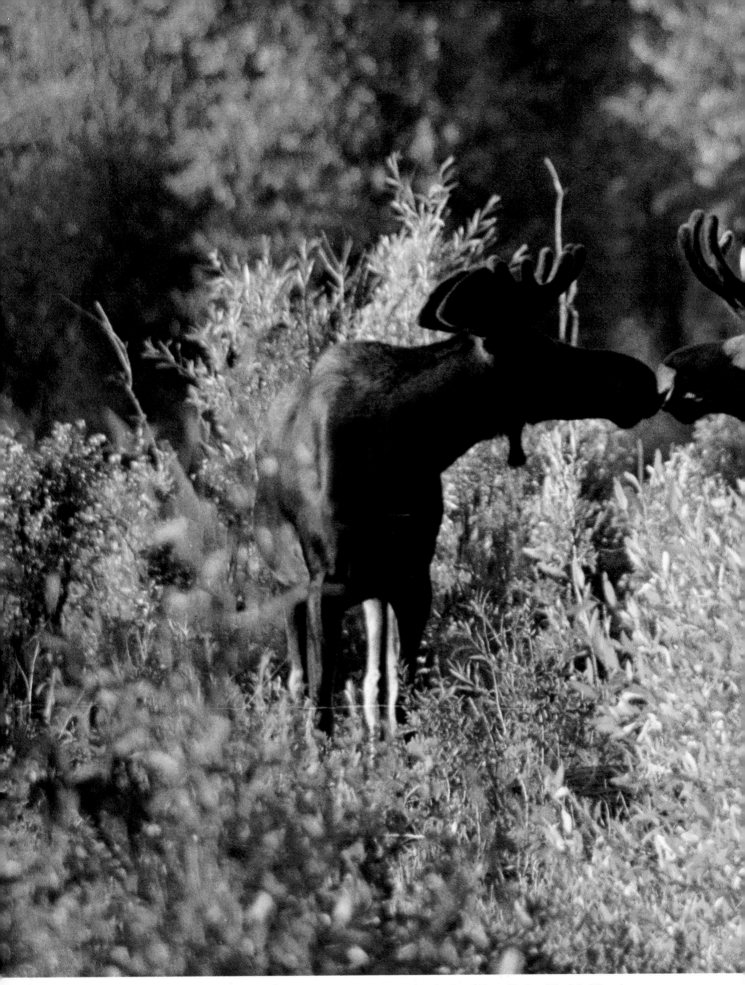

Wilderness Greeting: Moose meets moose at a campground in the Grand Teton National Park in Wyoming. Photo by Clarence E. Hoiland of Richfield, Minn.

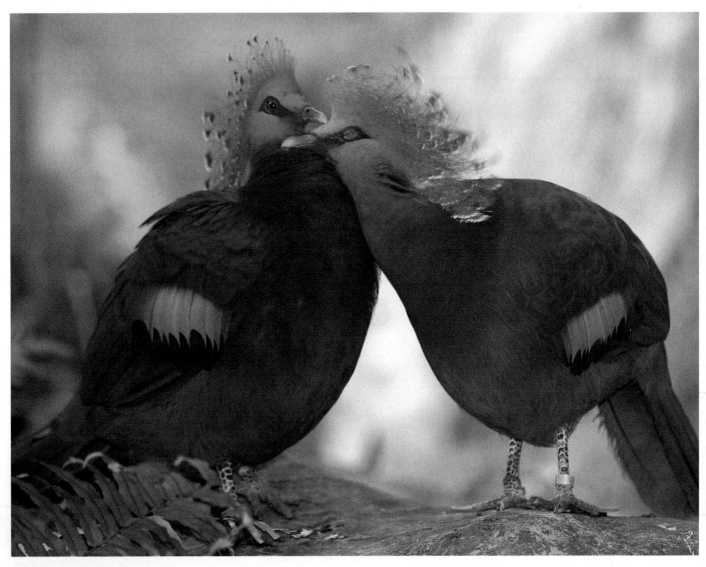

Royal Courting: Victoria Crowned pigeons, among the rarest of the species. Photo by Bill Surina of Marathon, Fla.

He Said, She Said: Blue and gold macaws in Silver Springs, Fla. Photo by Karen R. Caturano of Ocala, Fla.

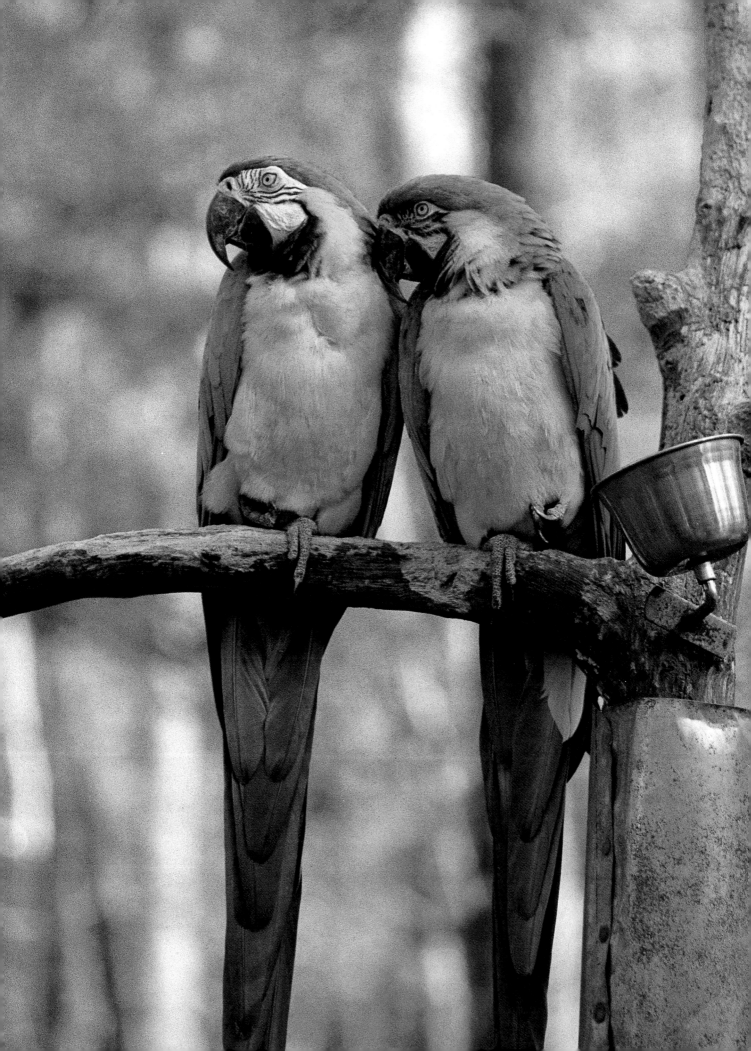

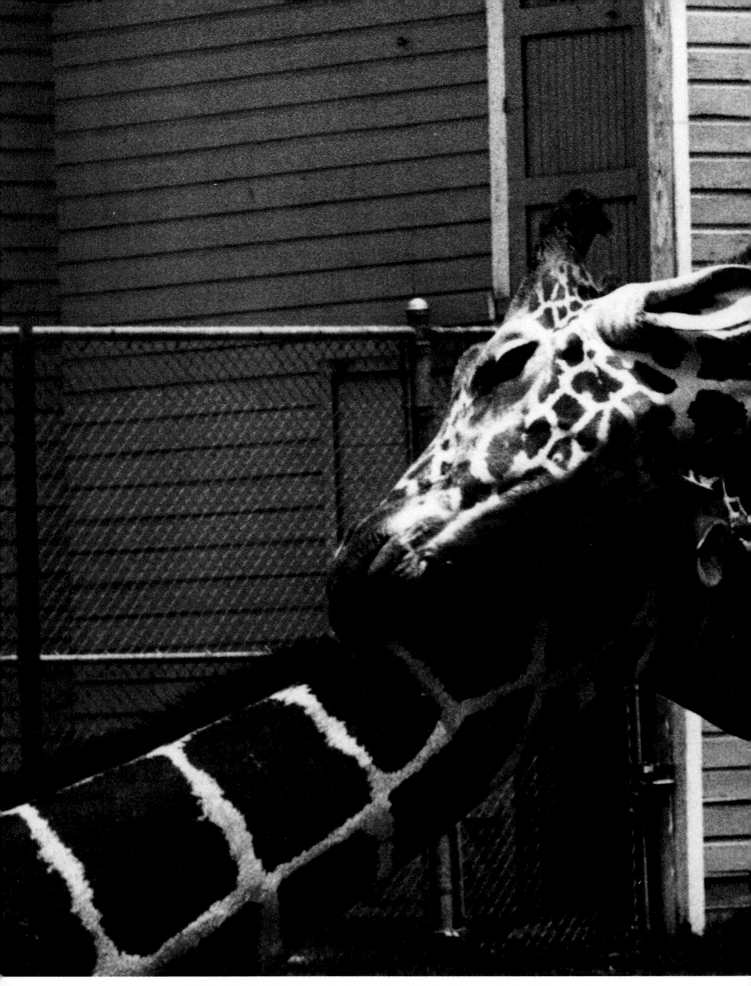

Necking: The giraffe family at the Houston Zoo. Photo by Maureen Cook of Arlington, Tex.

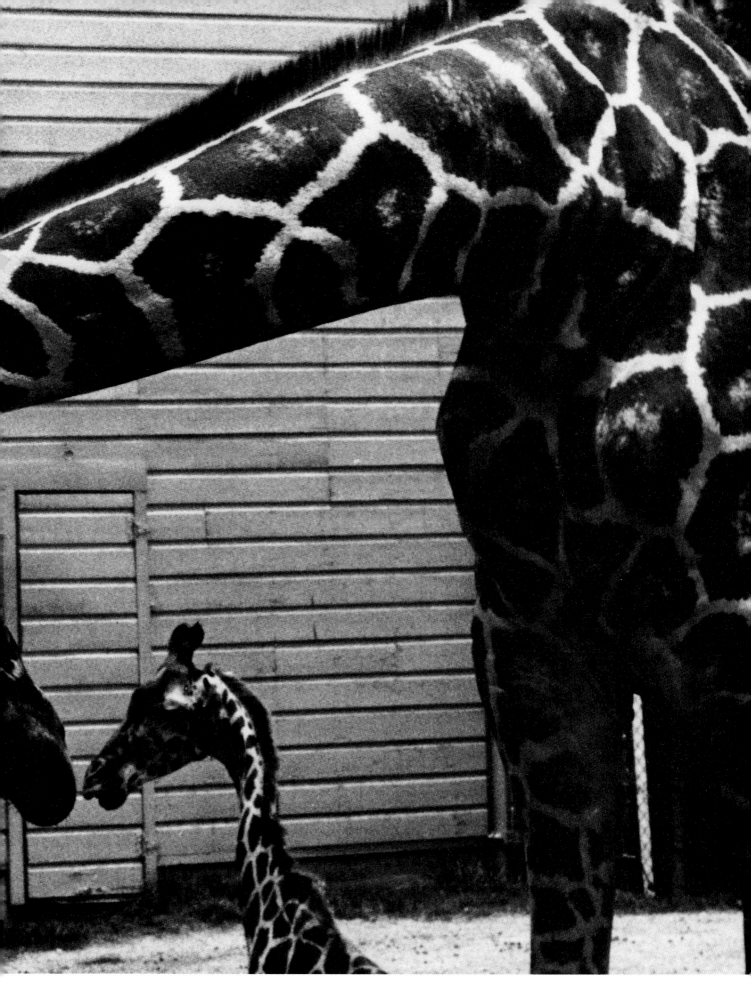

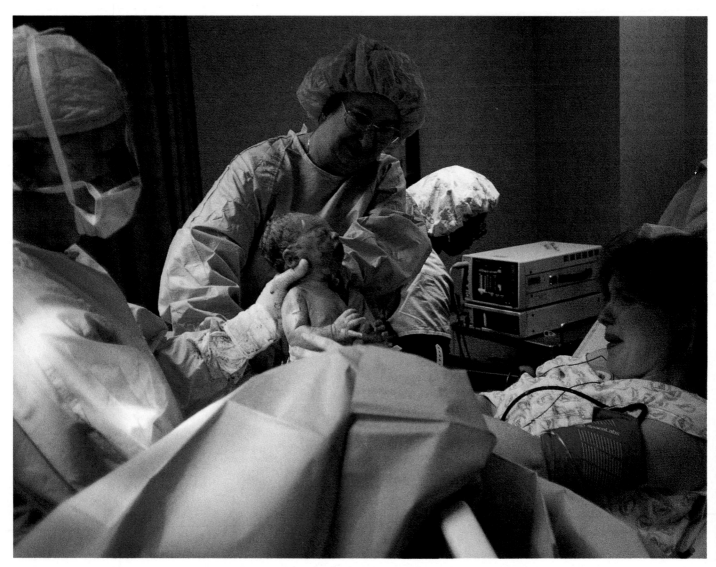

Welcome to My World: Lisa Baggett gets her first look at her son, Michael David at 5:52 a.m., on March 6, 1992.
Photo by his father, Kerry Baggett of Taylors, S.C.

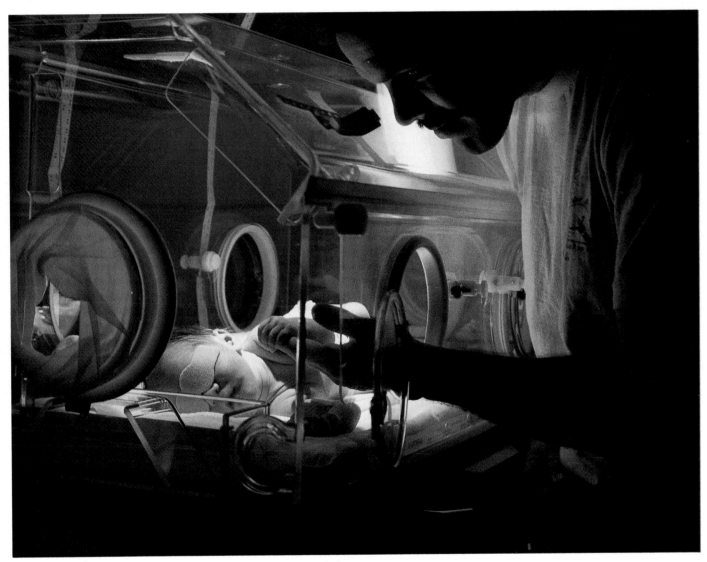

"Goodnight, Ariel." T.J. Maroon with his 3-day-old firstborn, who has to remain in the hospital to be treated for jaundice.
Photo by Ariel's mother, Angela Maroon of Sacramento, Calif.

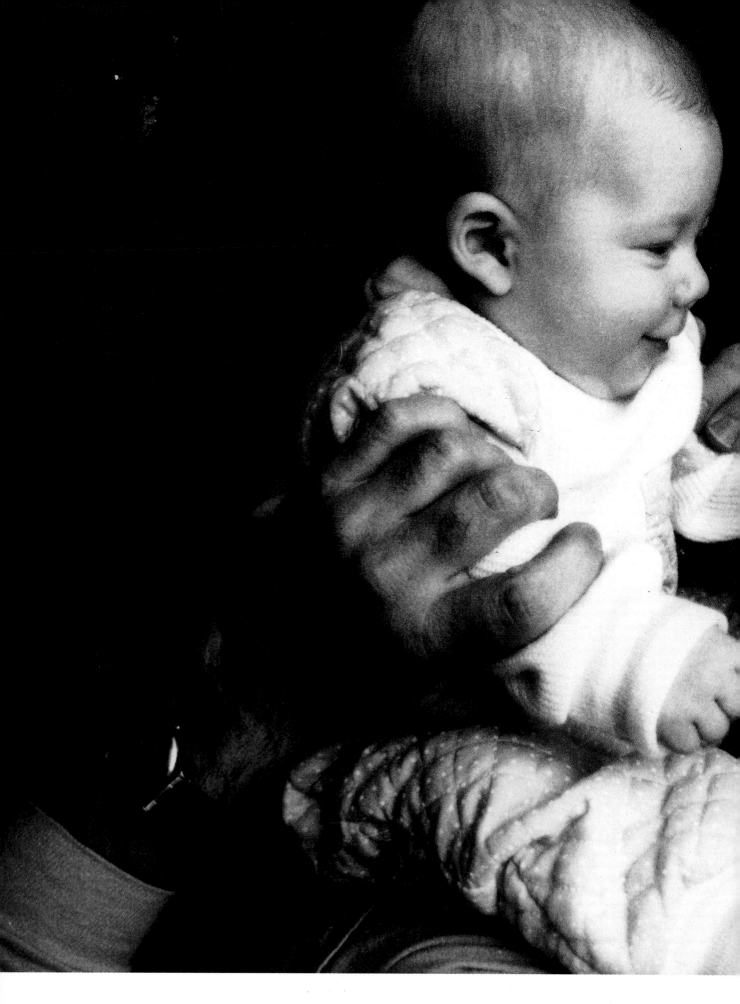

Eyefuls of Love: Arthur Enteman and his son, Aaron, 4 months. Photo by Aaron's grandmother, Eileen Enteman of Chatham, Ill.

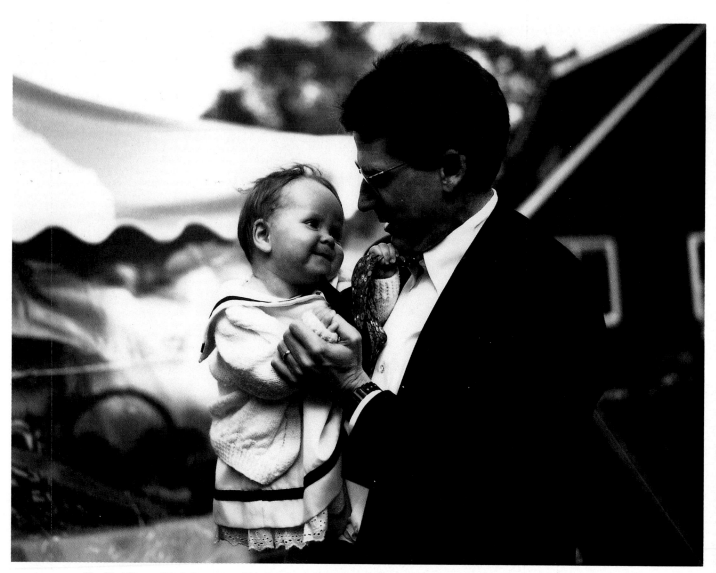

Her First Dance: Mark Stewart and his daughter, Casey, 9 months, at a friend's wedding in Thousand Island Park, N.Y.
Photo by Lori Price of Washington, D.C.

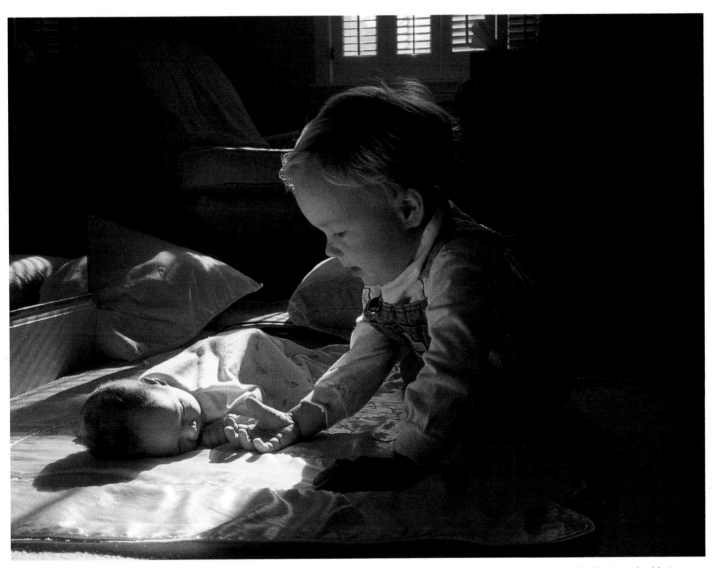

"She's Scared, and I'm the Big Brother." That's what Alexander, 3, told his mom when she found him sitting quietly beside his 2-week-old sister, Victoria. Photo by their mother, Christine L. Nazar-Ronn of Marietta, Ga.

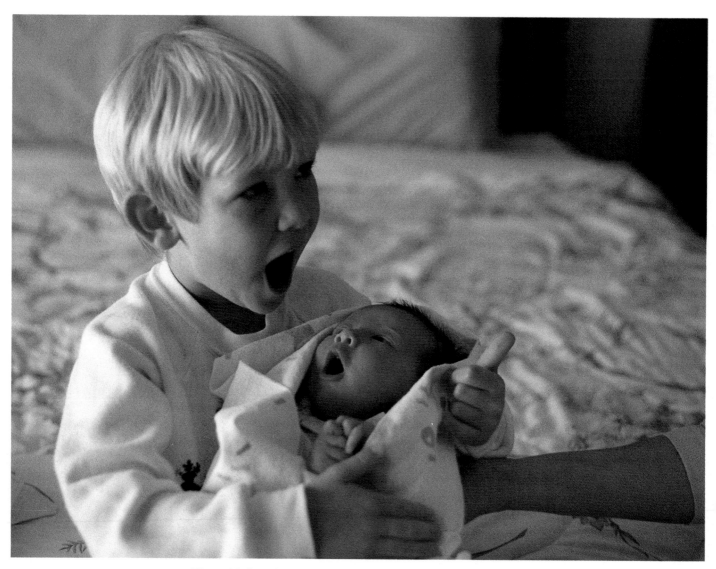

"Happy Mother's Day!" Nathan Harper, 5, presents his gift. Photo by his grandmother, Billie J. Trahin of Baxter Springs, Kan.

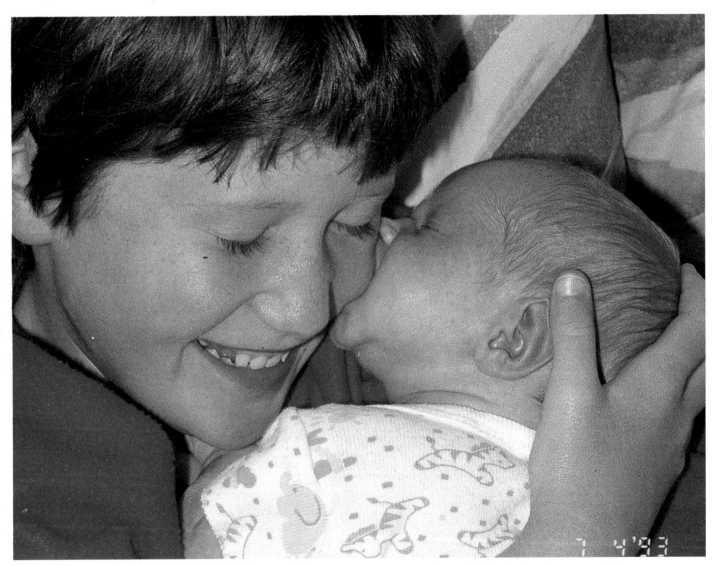

Richard Evarts, 2 weeks old, appears to take a bite out of his big sister, Casey, 10—but she doesn't seem to mind.
Photo by their mother, Heather Evarts of Dallas, Tex.

67

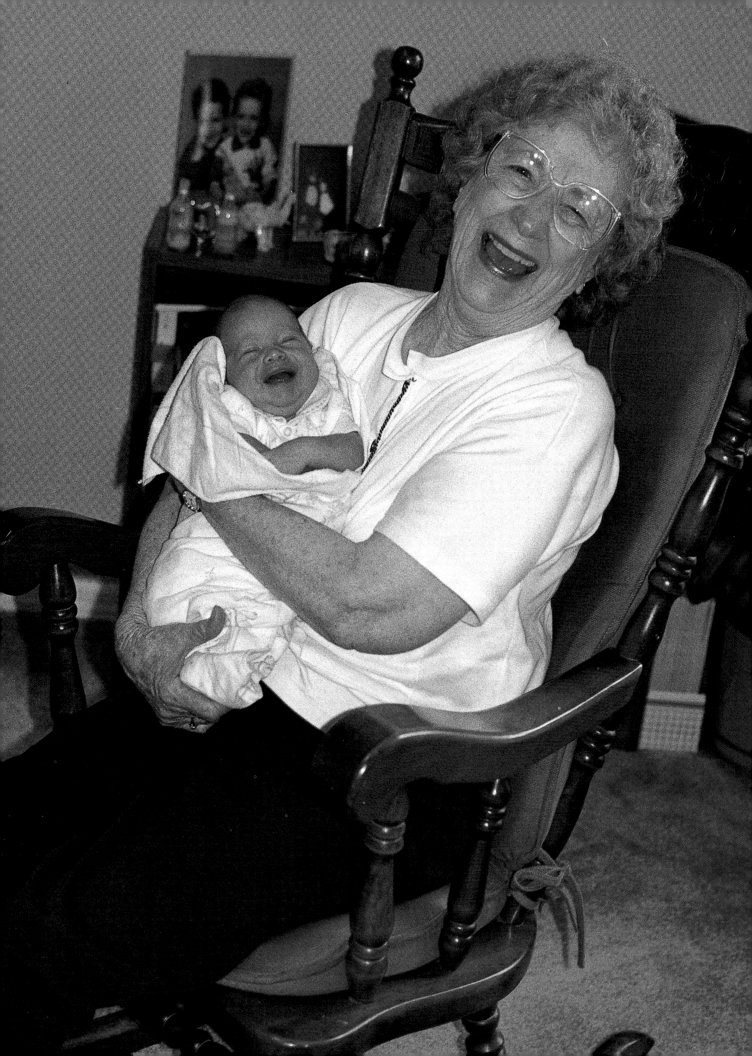

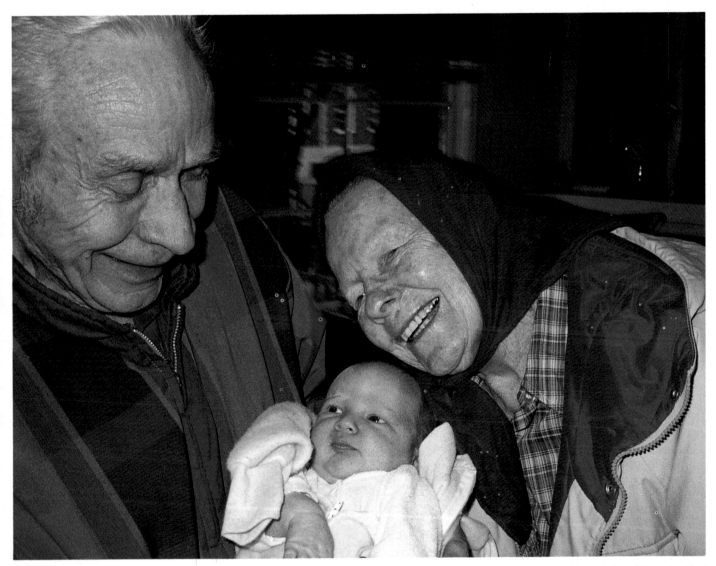

New Neighbor: Herb and Fran Brazil of Medford, Ore., meet month-old Daniel Flaxman. Says Daniel's mom, Kelly Flaxman of Medford, who took the picture: "They are like grandparents."

They Love To Laugh: Lauren Valentine, three weeks, with her grandmother, Josephine Palmer, 71. Photo by Lauren's mom, Denise Valentine of Sarasota, Fla.

69

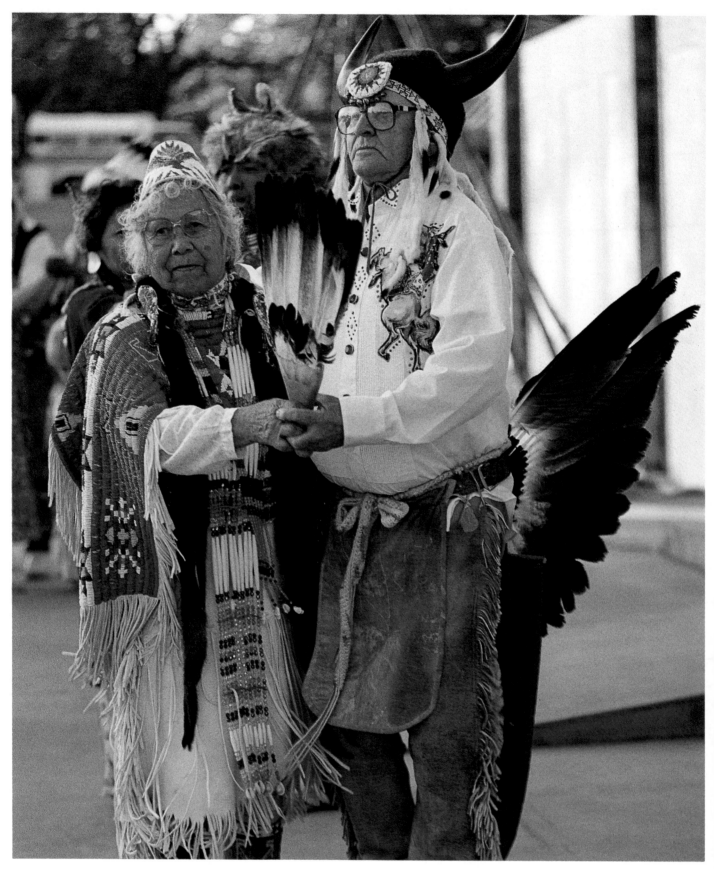

Tribal Love: Lenore and Lester Lewis peform the Owl Dance at Yakima Nation celebration in Richland, Wash. Photo by Jeff Fulks of Richland, Wash.

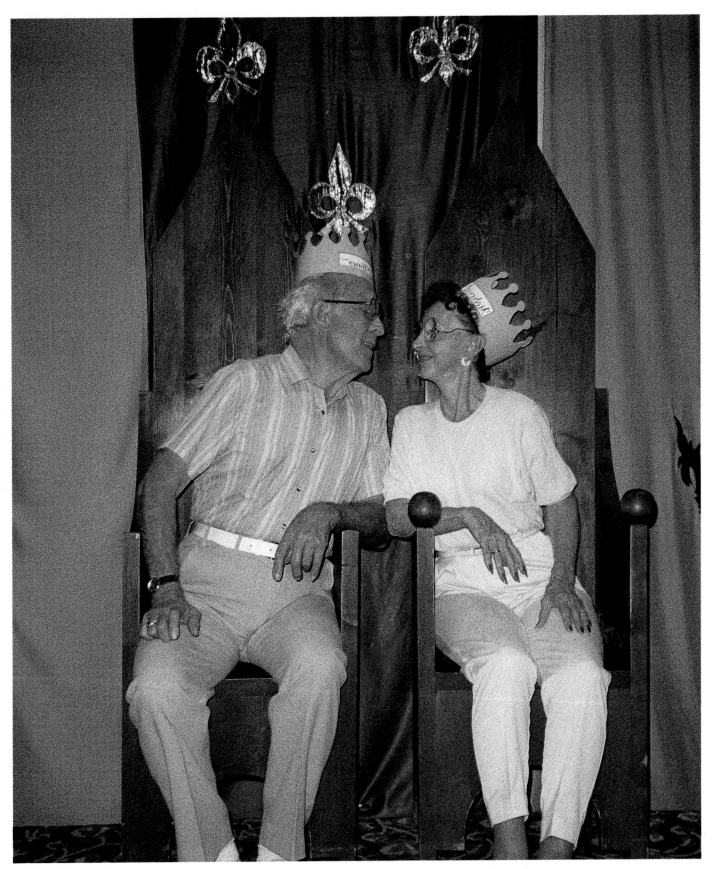

"You're the Queen (Make That the King) of My Heart." Margarita McKenna of Summerland Key, Fla., took this photo of her in-laws, Walter and Opal McKenna, at the Medieval Times Dinner Theatre in Orlando, Fla.

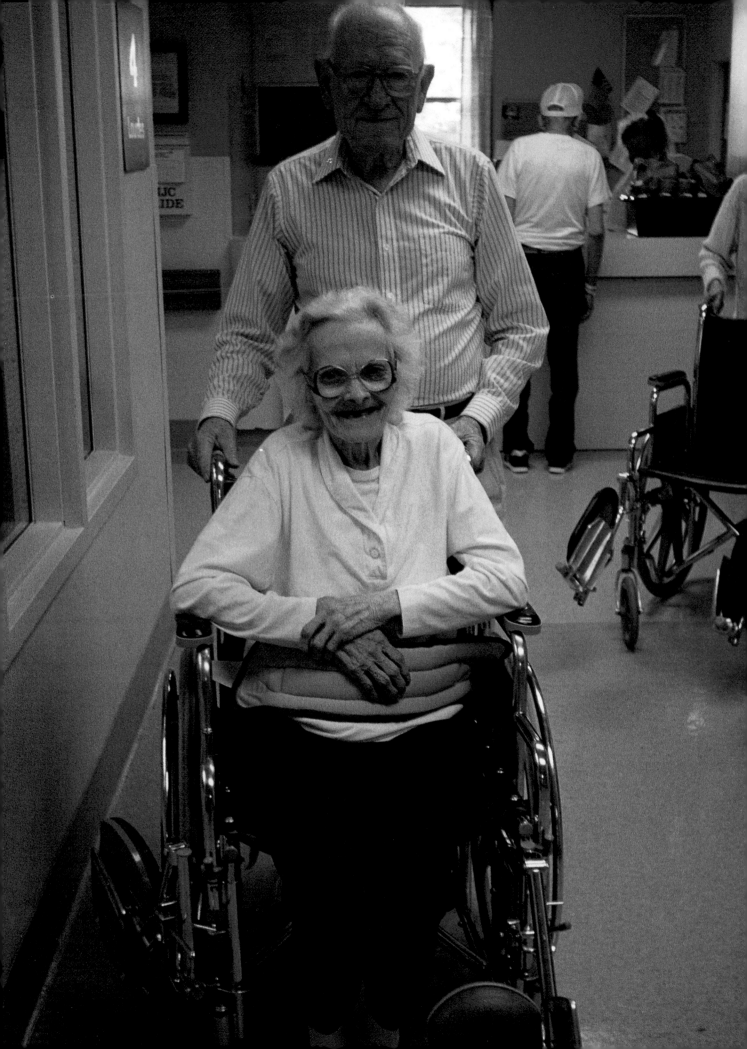

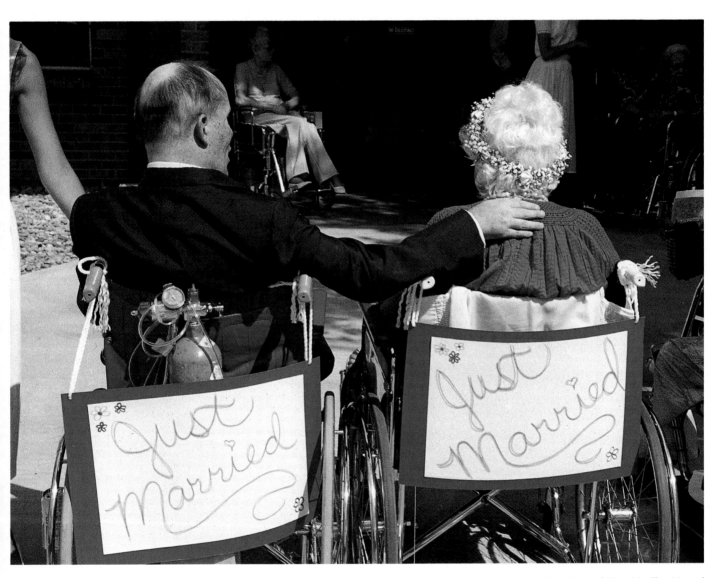

Just Married: Ron Mueller, 58, and Thelma Dowling, 79, exchanged wedding vows outside the Bear Creek Nursing Center in Morrison, Colo., where they were residents. Both are now deceased. Photo by Sandy Chapman of Littleton, Colo.

In Sickness and in Health: Thomas Murph, 85, and his wife, Ruth, 86, of Dayton, Ohio, see things through together. Photo by Grace Vallo of Trotwood, Ohio.

*Lasting Love: Elizabeth Giosa, 95, of New Hyde Park, N.Y., and her husband of 70 years, Pulviano Giosa, now deceased, on his 91st birthday.
Photo by Dr. Nicholas Giosa of Wethersfield, Conn.*

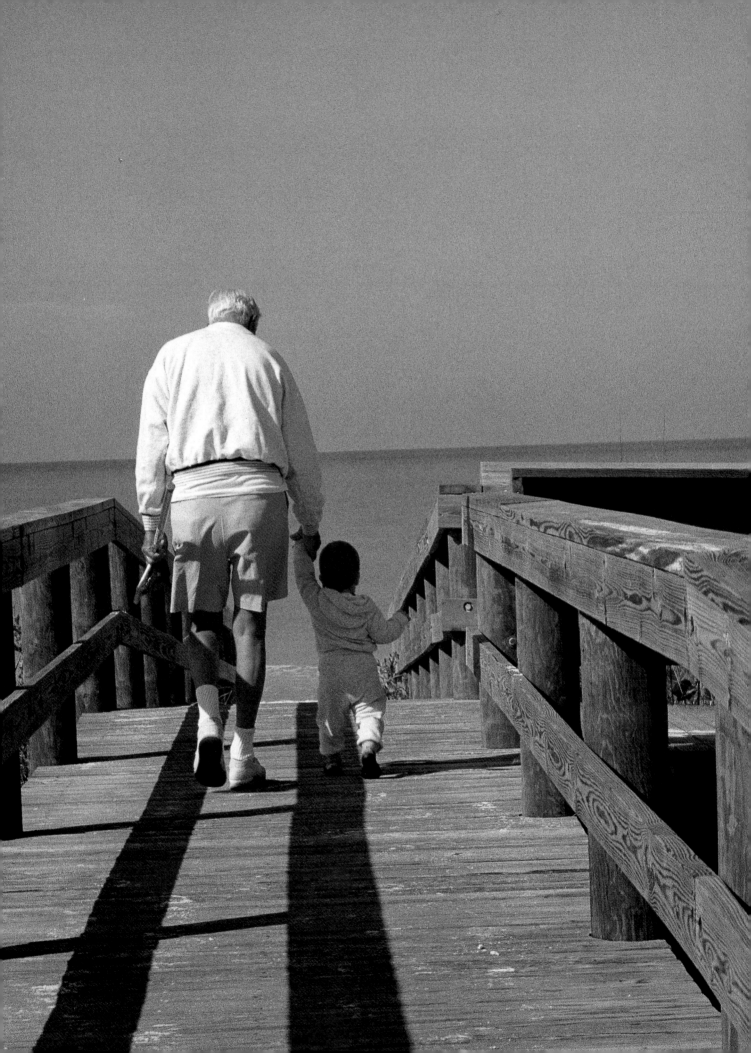

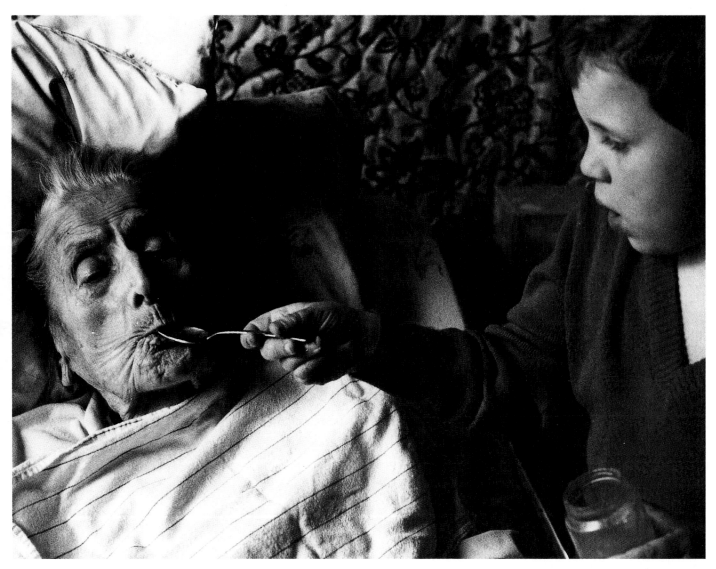

Loving Care: Richard Bayless, 4, and his great-grandmother, Mamie Sylvester, 99. Photo by his mother, Charmayne Bayless of DeSoto, Tex.

Let's Take a Walk: Trevor D. Prell, 1, and his grandfather, Frank Williams, head for the beach in Bonita Springs, Fla. Photo by Trevor's mother, Carol L. Prell of West Olive, Mich.

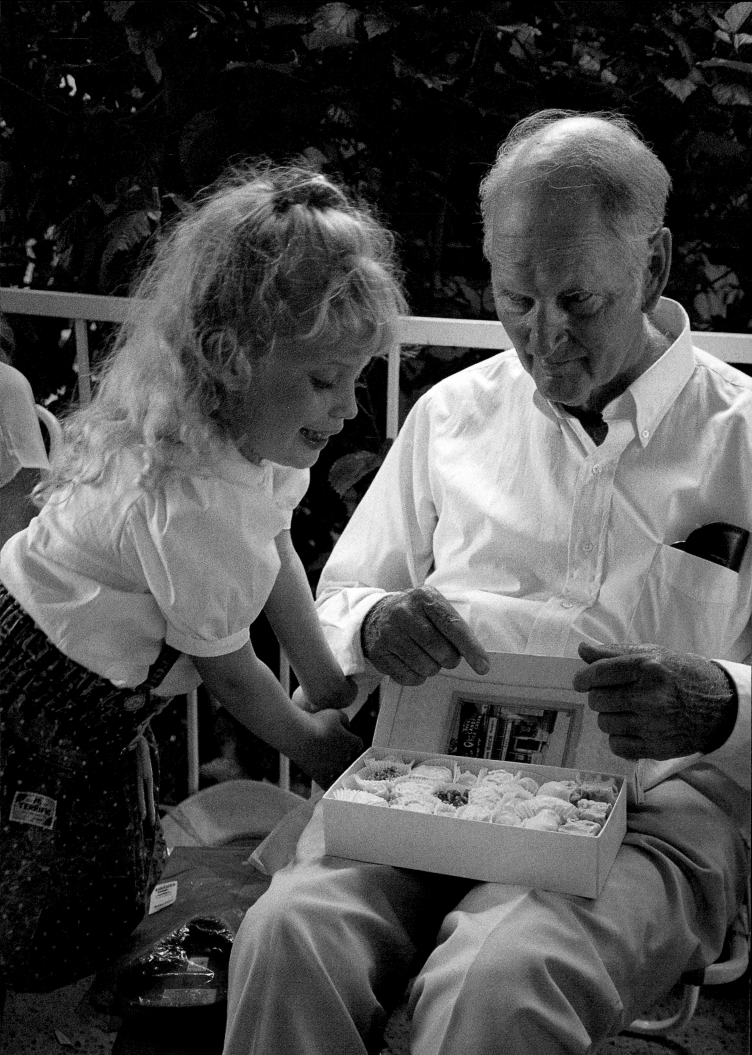

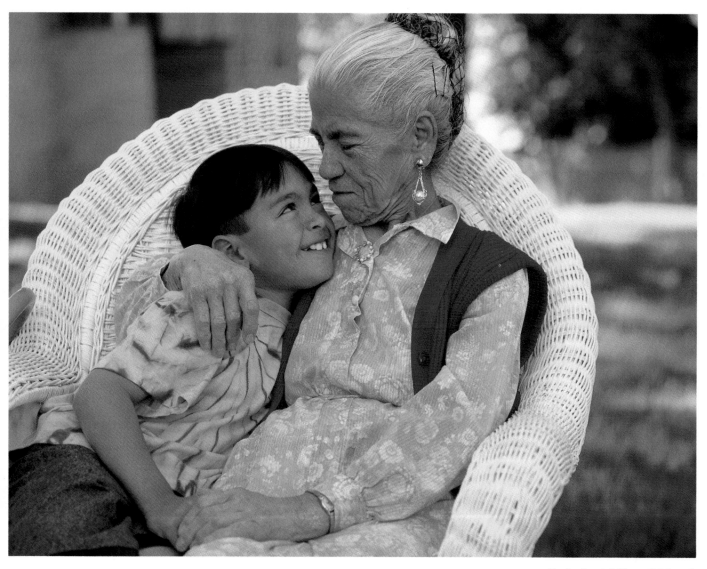

You're Special: Kenneth Meza, 9, with his grandmother, Josephina Meza, 80, of Goleta, Calif. Photo by Sister Jane E. Alves of Boston, Mass.

Father's Day: Holly Fischer, 5, and her grandfather, Ray Young, 73, share a box of candy. Photo by Holly's other grandfather, David Fischer of Irvine, Calif.

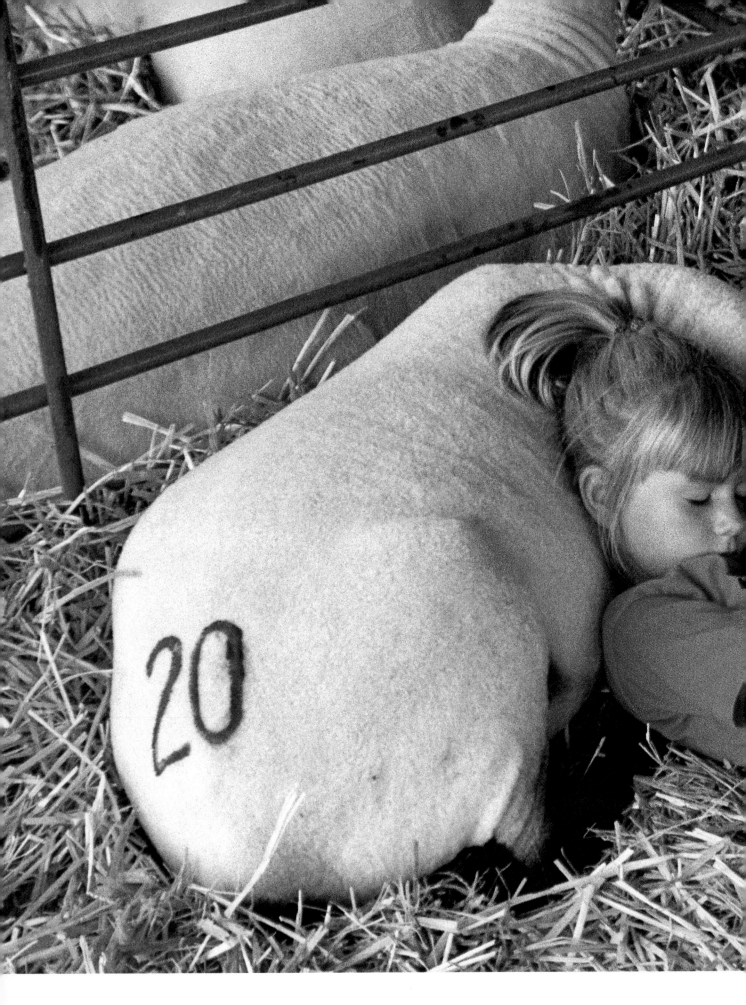

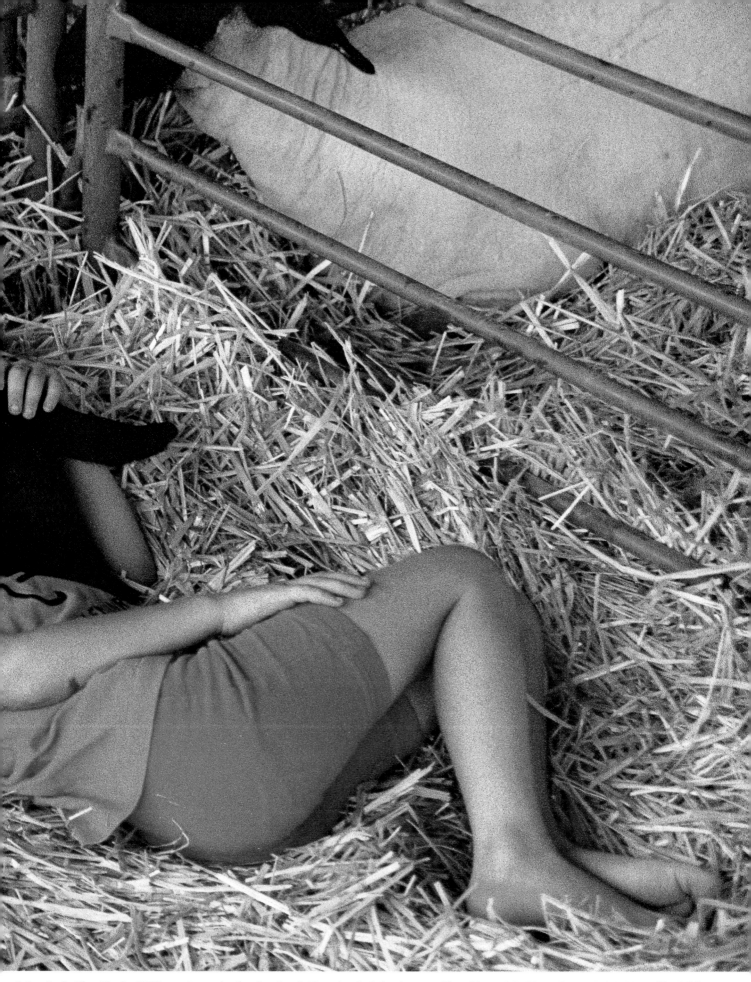

Asleep in the Hay: Kendra Williams, 6, rests her head on Lamb Chop shortly before it won a blue ribbon at the Placer County Fair in Roseville, Calif. Photo by Anne Seeley of Sacramento, Calif.

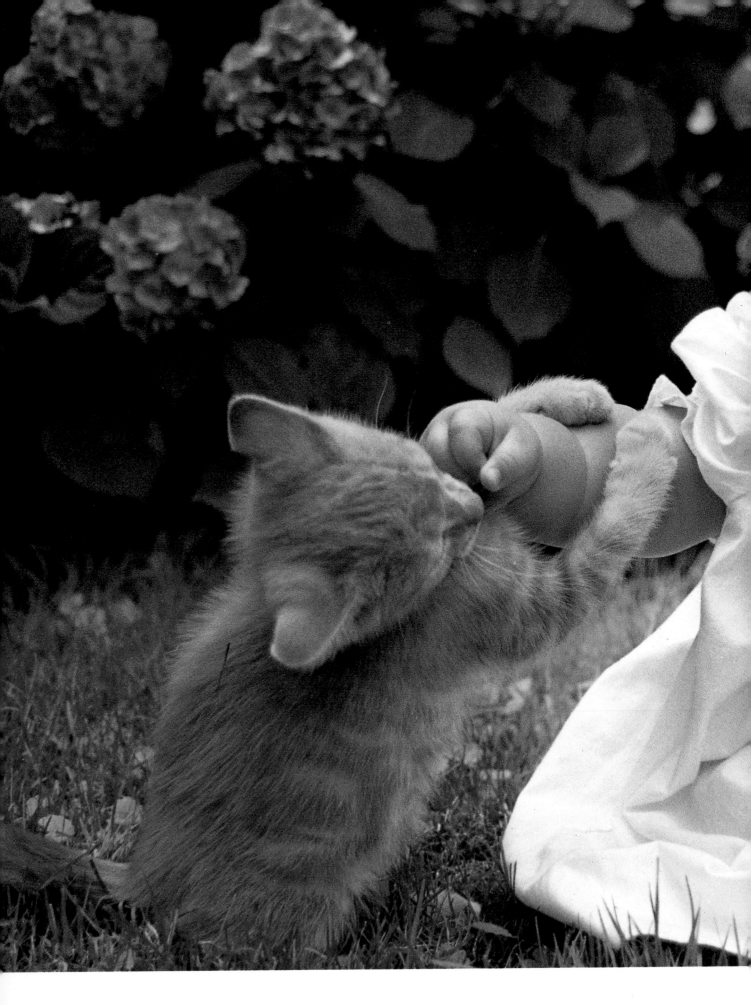

My Little Playmate: Mary Wynne Lawrence, 6 months, meets Figaro, a new friend, in her grandmother's backyard.
Photo by Mary's mother, Annette F. Lawrence of Roanoke, Va.

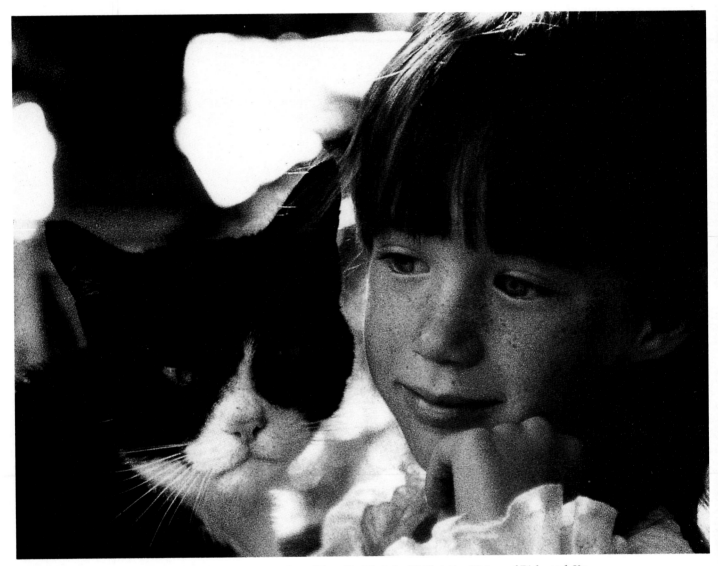

Adoration: Emily Ann Monroe, 12, and Frenchie. Photo by M. Christine Watson of Richmond, Va.

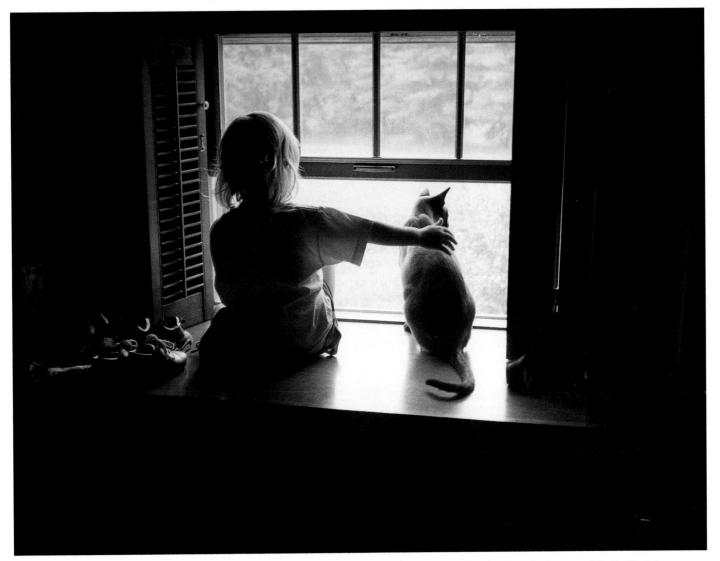

Stuck Inside: Jessica Sims, 3, and Lillie watch the rain together. Photo by Jessica's grandmother, Dorotha Stevens of Hallsville, Mo.

Playmates: Ashley Alan Richey, 10, and Igg, 6 months. Photo by Bobbi Long of Terre Haute, Ind.

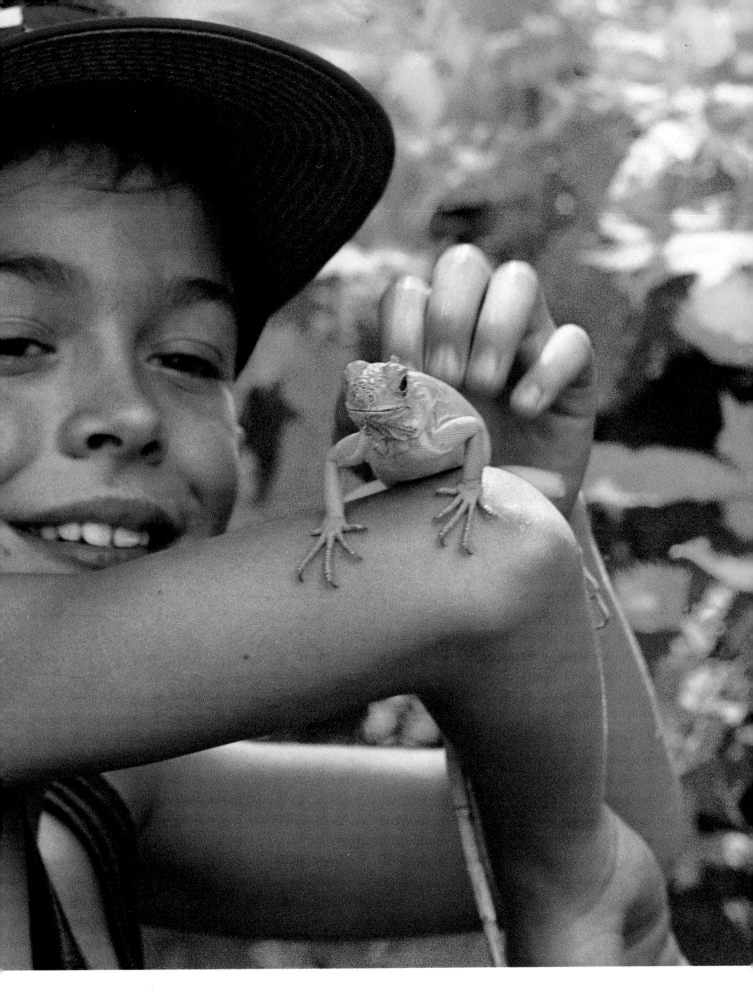

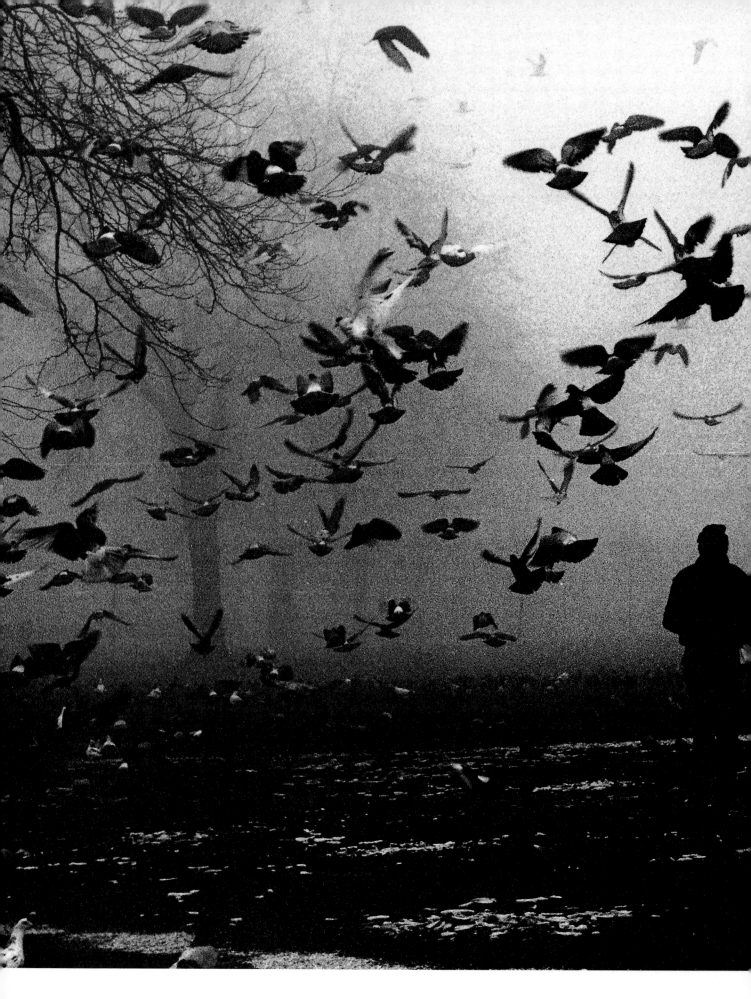

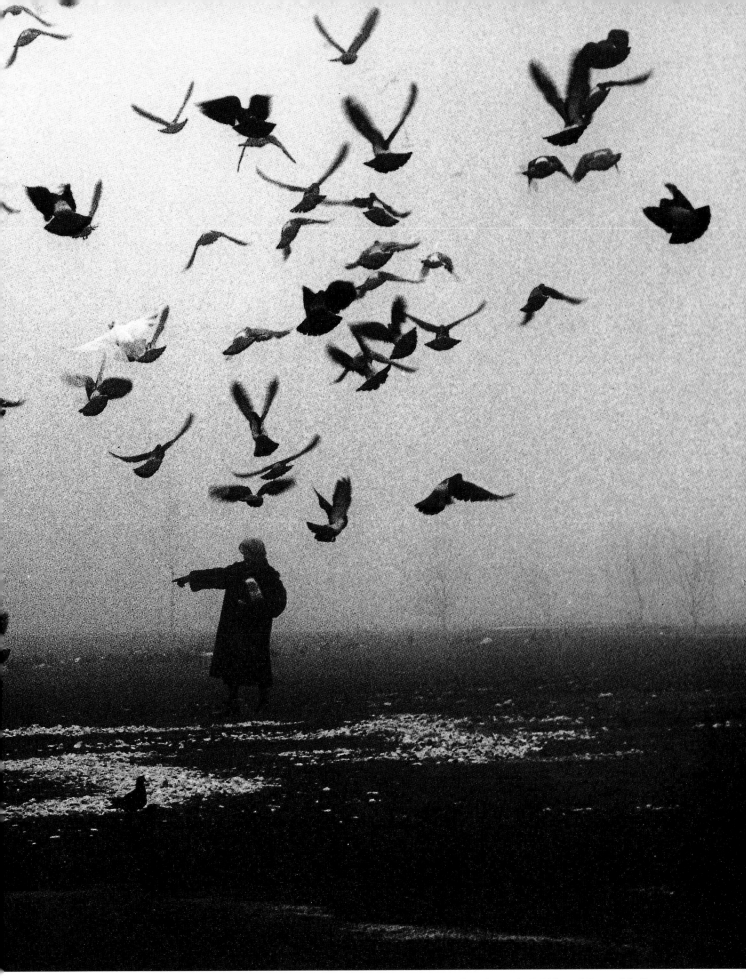

In the Mist: An elderly couple feed a flock of pigeons in Chicago's Lincolnwood Park. Photo by Paula F. Piekos of Greenwich, Conn.

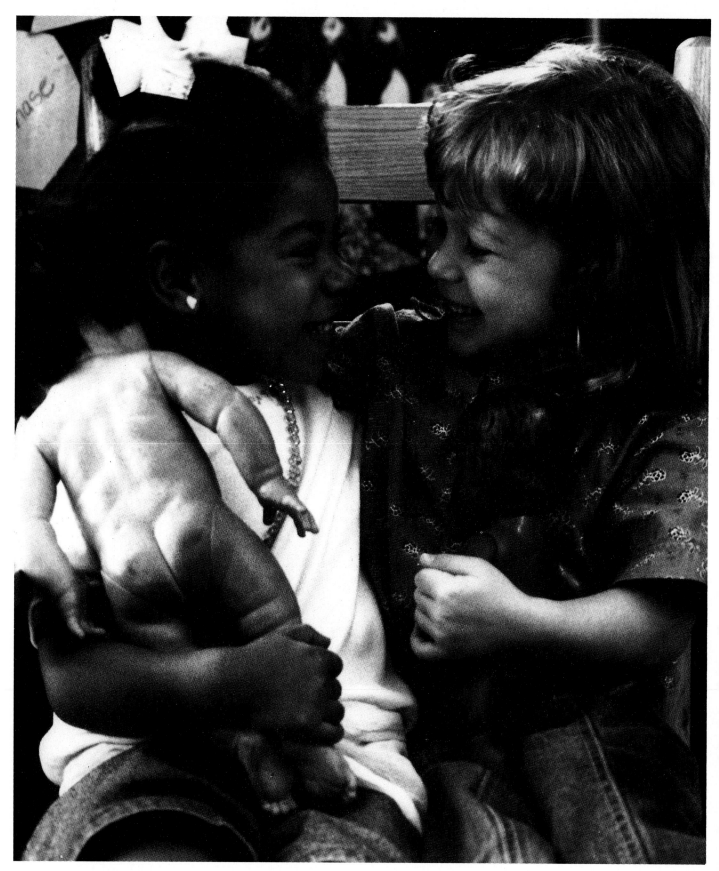

Sharing Dolls: Brittney Gordon (l) and Ashley Wampler, both 3, enjoy playing together at a day-care center in Fort Wayne, Ind. Photo by Lori Eby Hunt of New Haven, Ind.

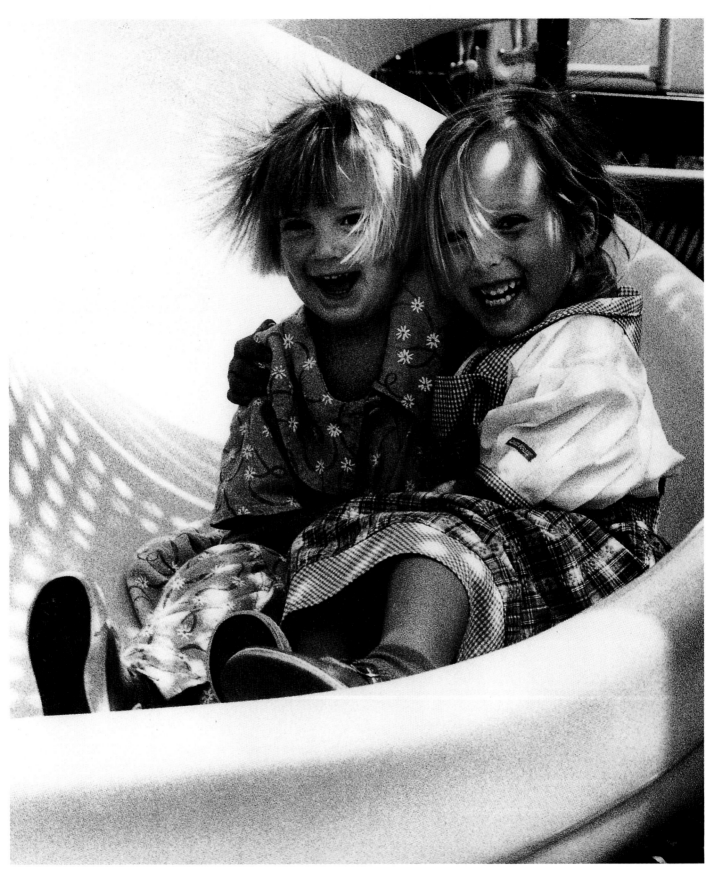

*Wheeeee! Ingrid Mangold (l), 3, and sister Hanna, 5, of Alexandria, Va., enjoy an afternoon at the park together.
Photo by their grandmother, Maggie Rogers of Alexandria.*

A Little Stroll: Sisters Elaine Anderson, 6, and Killette, 4, take in the sights at Seaside Village, Fla. Photo by their grandfather,
Dr. Lamar M.C. Smith Jr. of Birmingham, Ala.

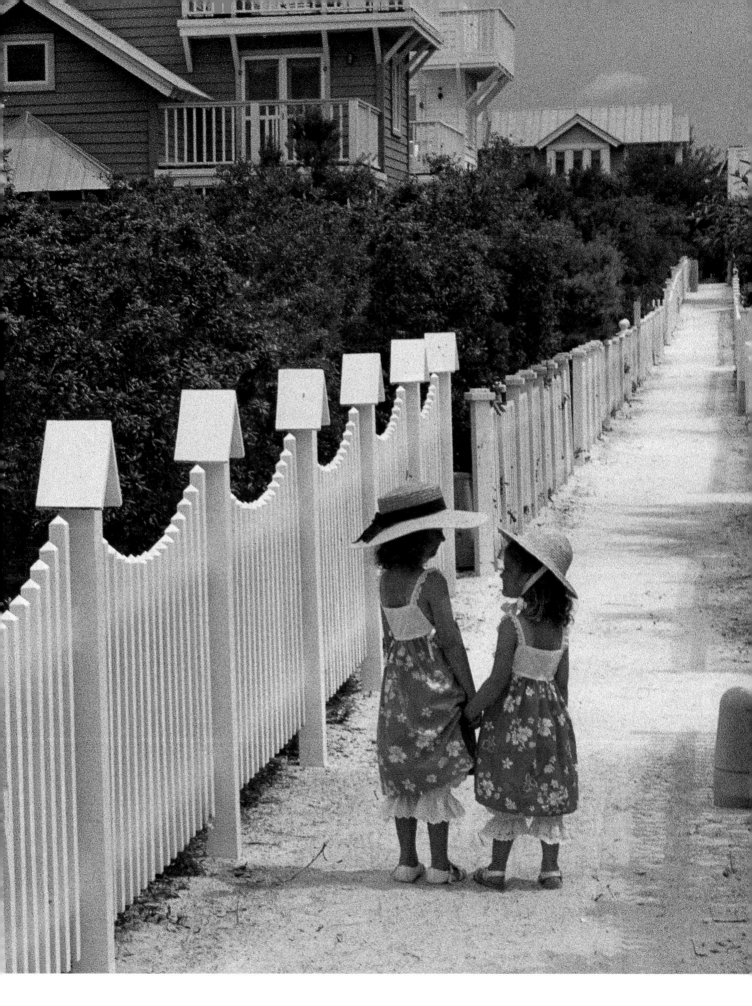

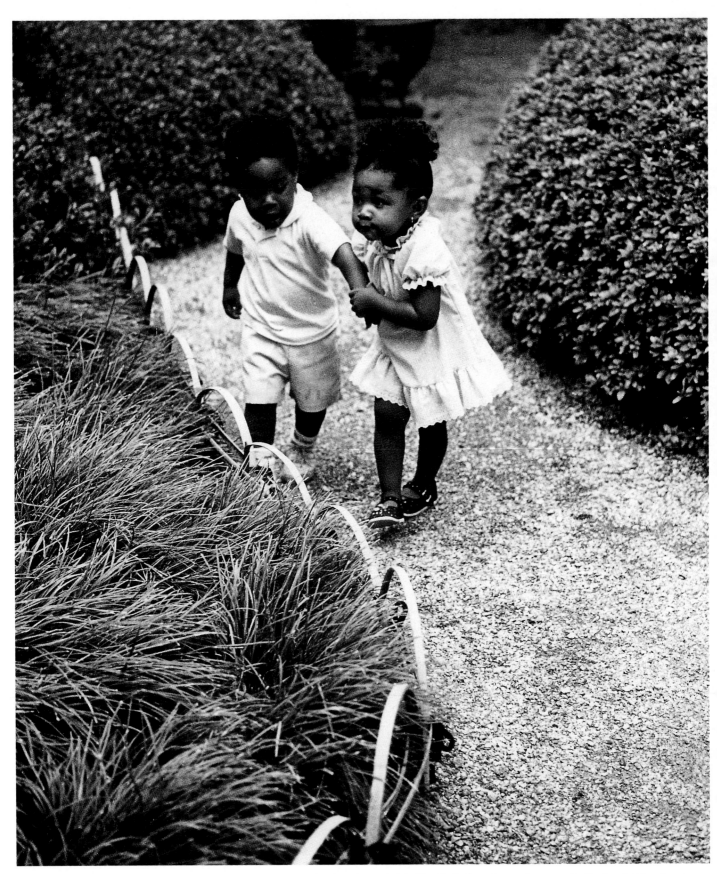

Down "Lover's Lane": R. Olivia Aikens-Cummings, 3, leads her friend, Austin Maddox (l), 2, through a pathway at the National Arboretum in Washington, D.C. Photo by Nestor Hernandez of Washington, D.C.

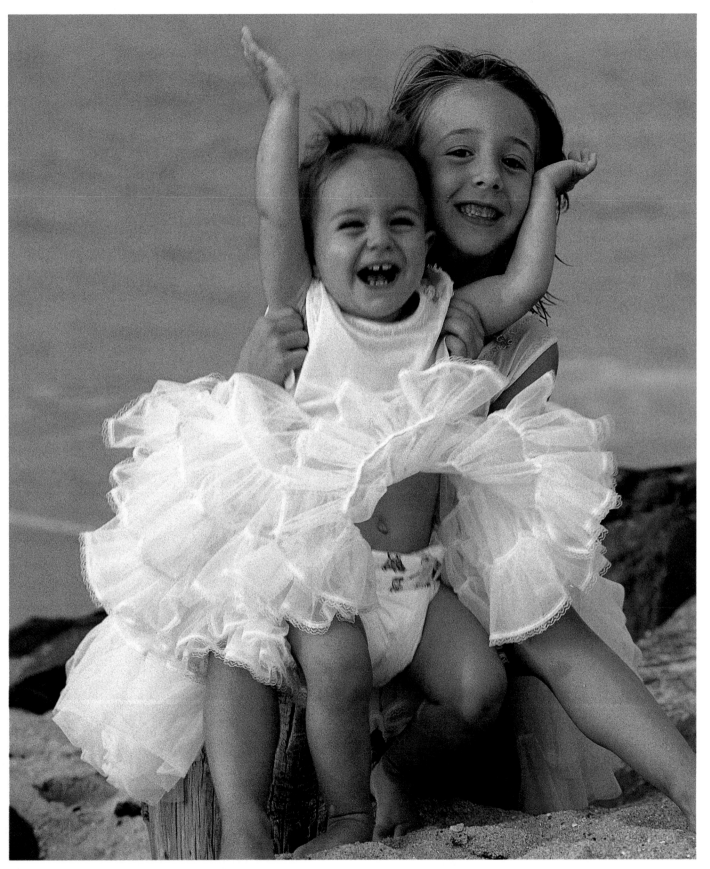

*Sisters—Friends For Life: Carlyn Vellante (l), 1, and her big sister, Kendra, 5, celebrate the sunset at the New Jersey shore.
Photo by their mother, Laureen Vellante of Short Hills, N.J.*

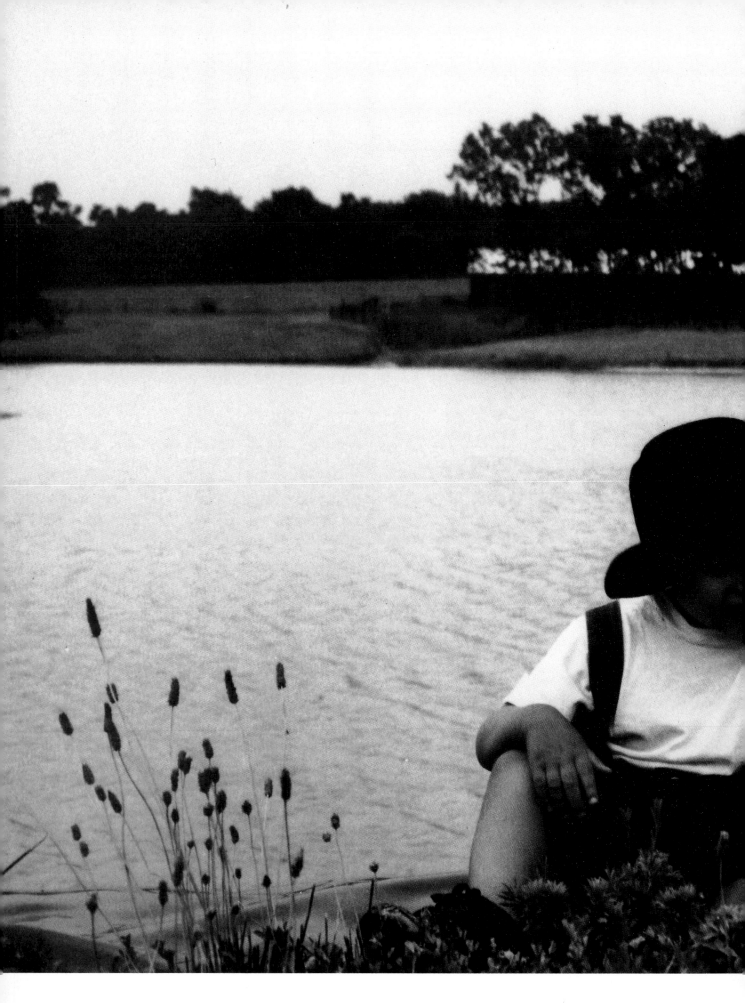

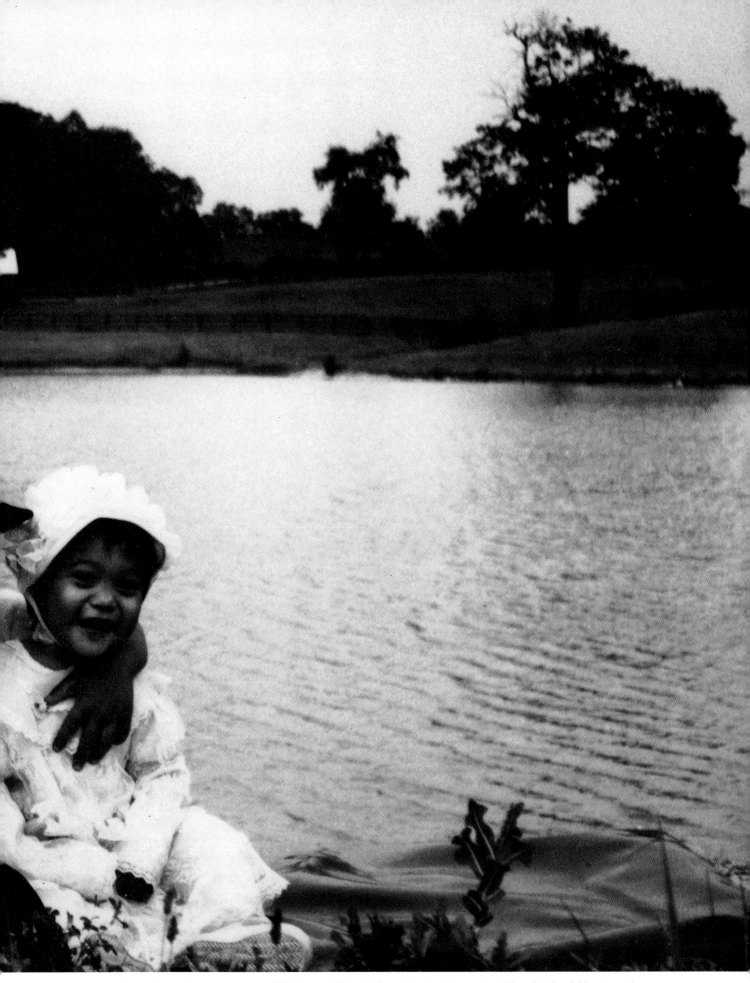

A Day at the Pond: Jonathan Herrera, 4, and his sister, Ashley, 2, dressed up for the occasion. Photo by the children's mother, Janie Herrera of Lexington, Ky.

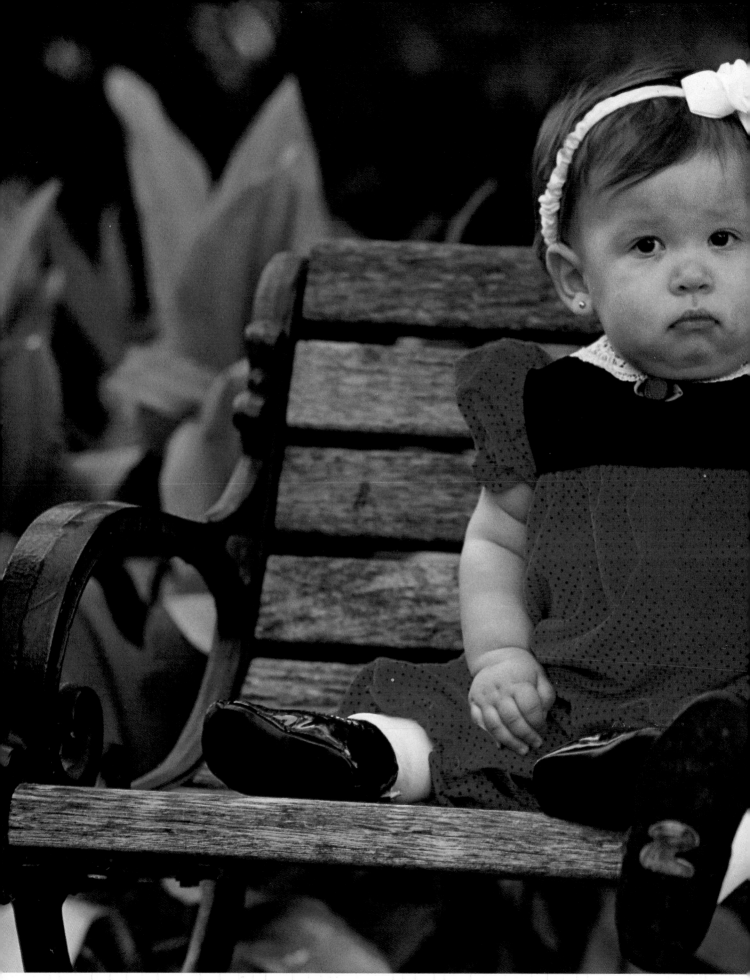

One Giggles, the Other Doesn't: Sisters Sarah Jane Gonzalez, 10 months, and Laurel Ann, 2.
Photo by their uncle, Frank Haecker of San Antonio, Tex.

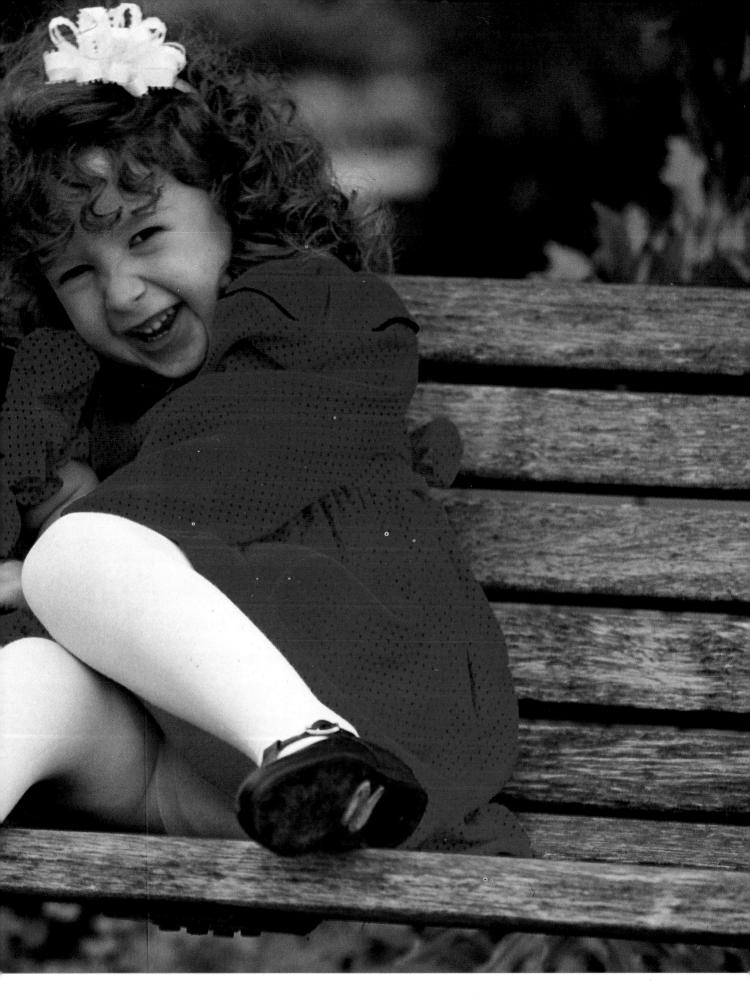

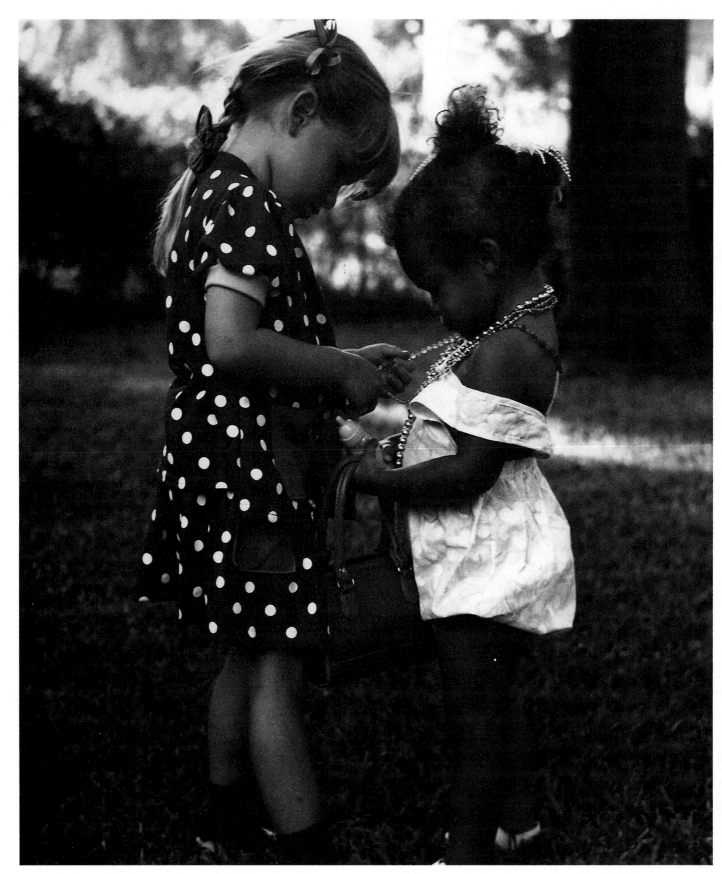

"There, That's Better." Erin Knebel (l), 3, gets necklace just right for cousin Lauren Knebel, 2. Photo by Heather Meyer of Austin, Tex.

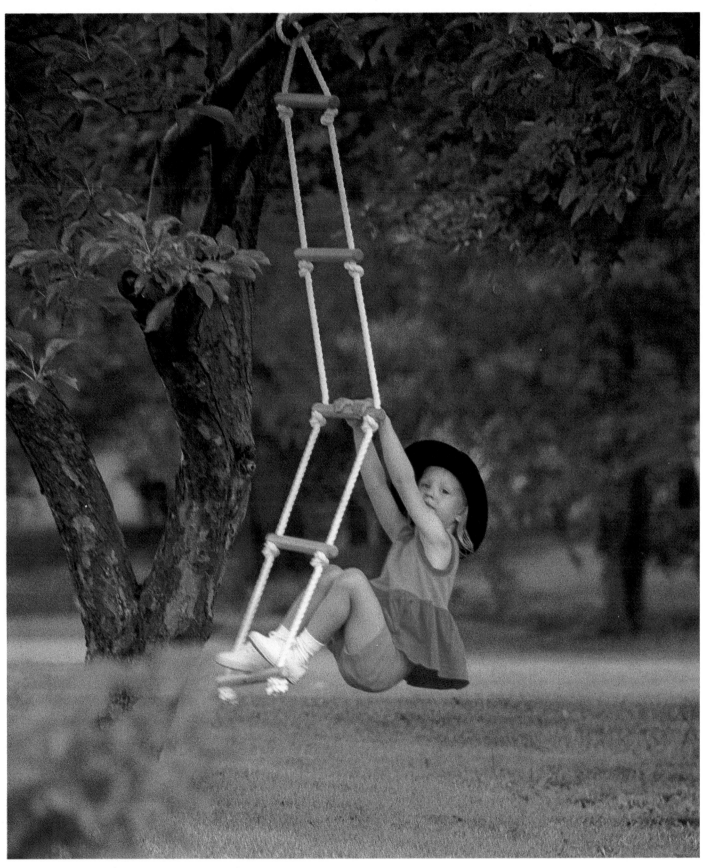

Waiting for a Push? Taylor Channing Bell, 4, in her grandparents' backyard in Uniontown, Pa. Photo by Deanne L. Kacmar of Smithfield, Pa.

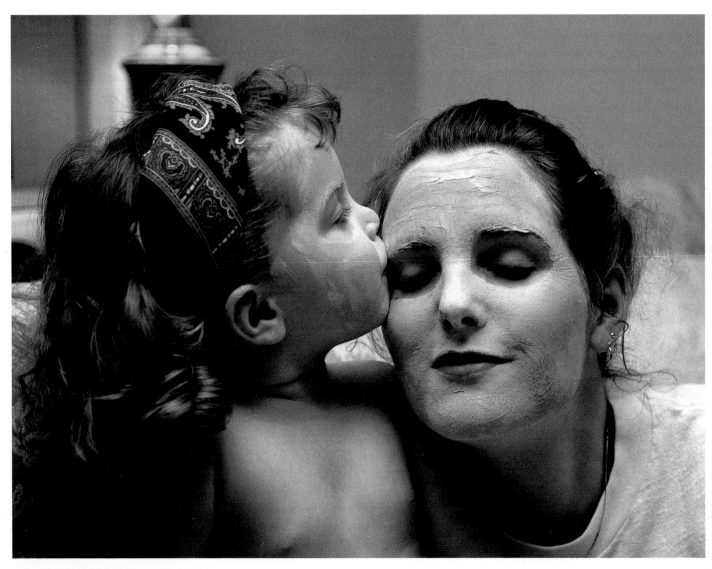

"Mmmm...Tastes Like Guacamole."
Laurie King, 3, and her mother, Susan,
enjoy a mud facial during their monthly
Mommy/Laurie Day. Photo by Laurie's
dad, Larry King of Newport News, Va.

Male Bonding: Ron Cusano and
his son, Craig, 4, get ready for a big
night out. Photo by Craig's mom,
Linda Cusano of Boardman, Ohio.

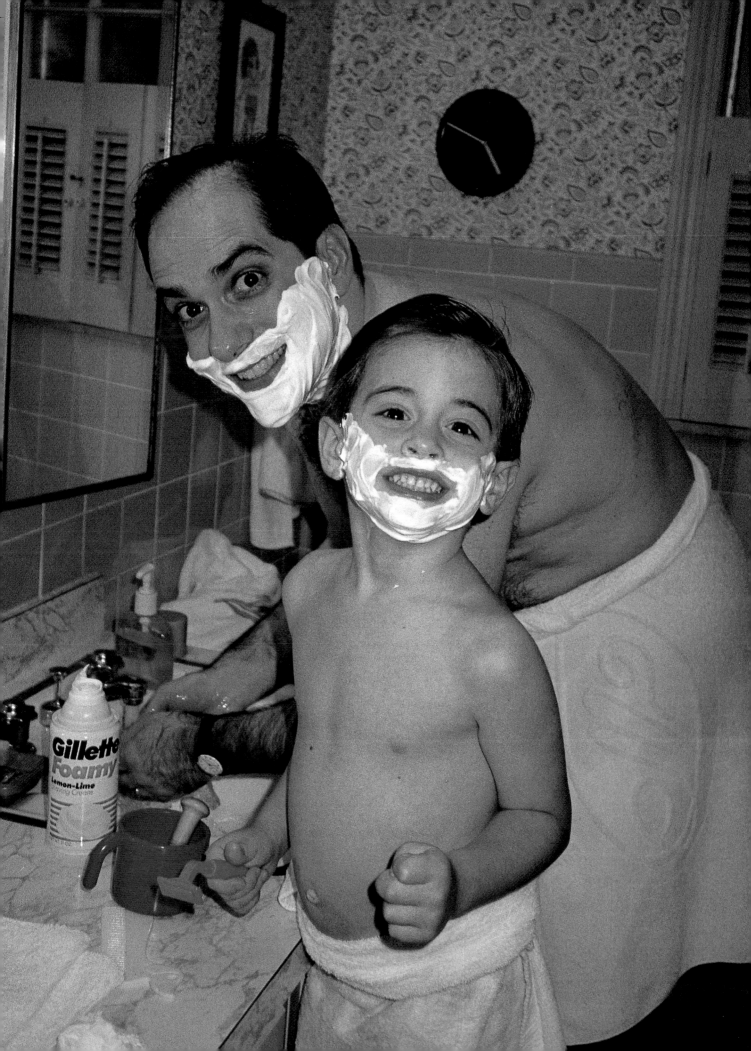

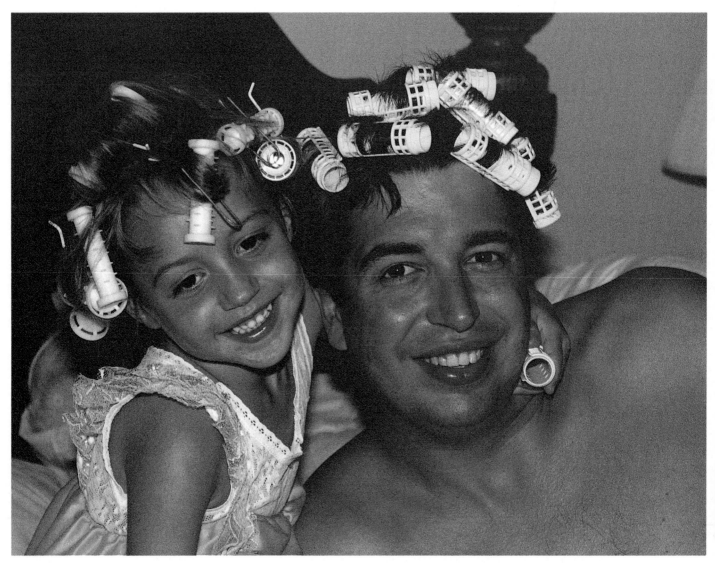

Daddy Is a Good Sport: Shelley Ann Bryant, 3, gets ready for her Aunt Lisa's wedding. Shelley's father, Lee Bryant, 32, joined in for fun.
Photo by Shelley's mom, Laurie Bryant of Savannah, Ga..

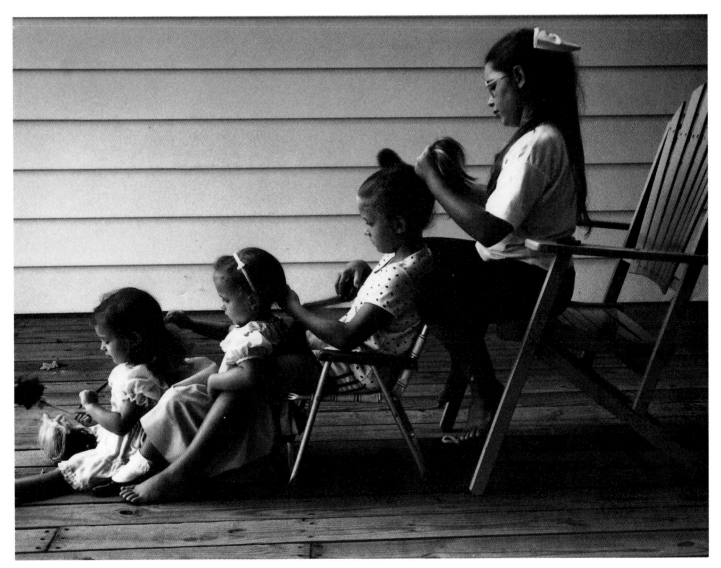

Best-Tressed: Danielle Geiger, 10, grooms the locks of her friend, Katie Cooper, 7, while Katie combs the hair of little Angel Geiger, 4, and Angel combs her little sister, Gabrielle, 3. Photo by Linda M. Geiger of Swartz Creek, Mich.

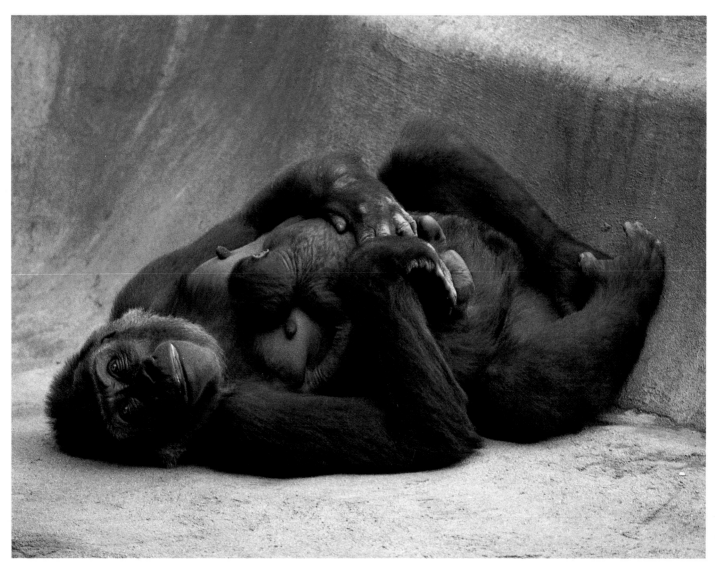

Gorilla mom and her baby have a cozy cuddle at the San Diego Wild Animal Park. Photo by Diana Hunter of Carlsbad, Calif.

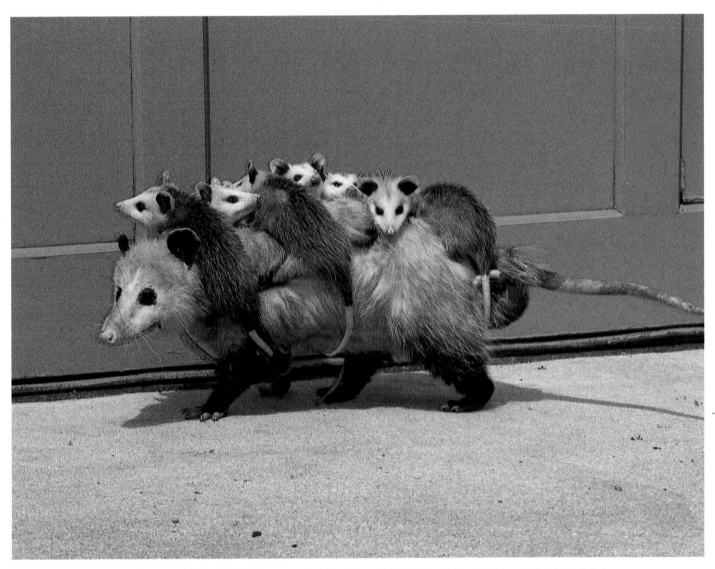

A Mother's Work Never Ends: The possum family take a ride. Photo by Starley S. Haines of South Bend, Ind.

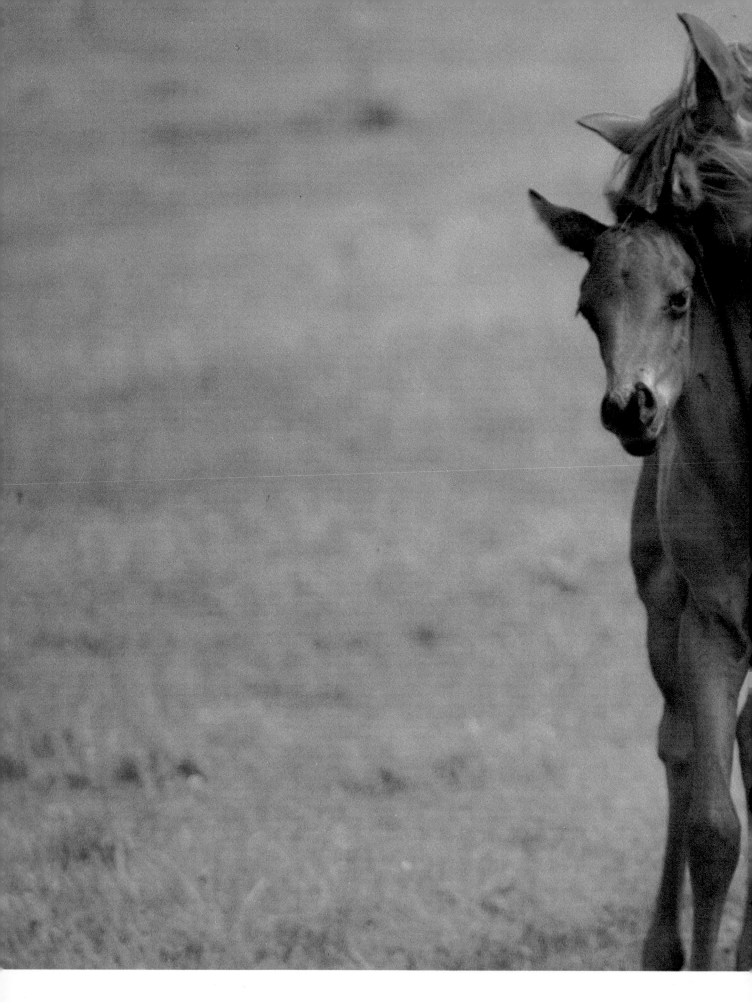

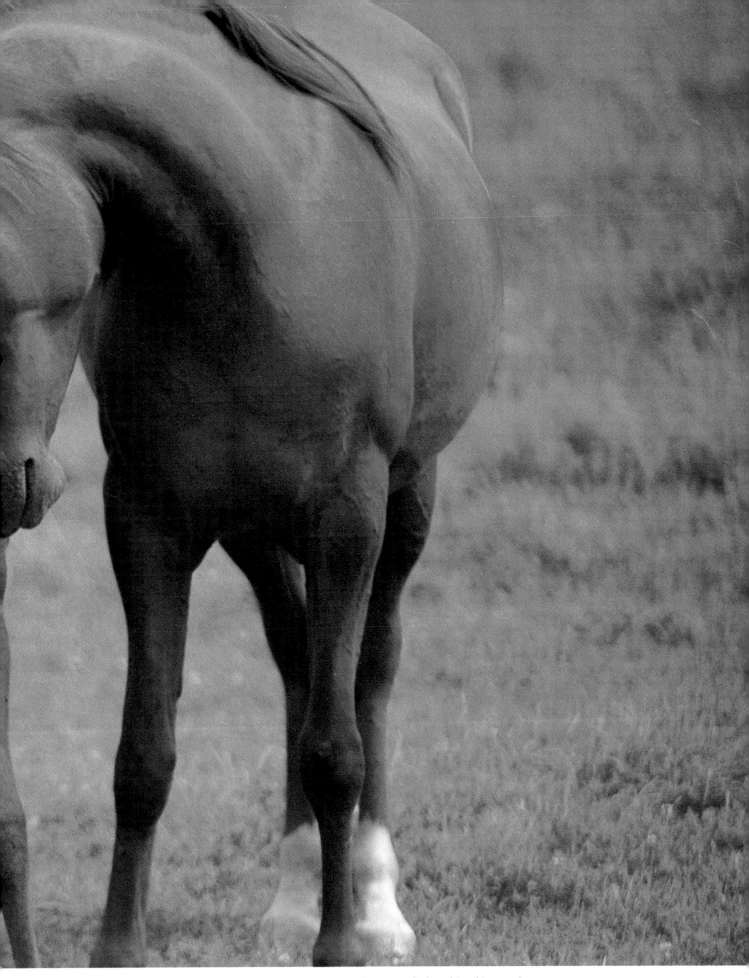

Mothering: Arabian mare and foal. Photo by Barry Blocher of Southington, Conn.

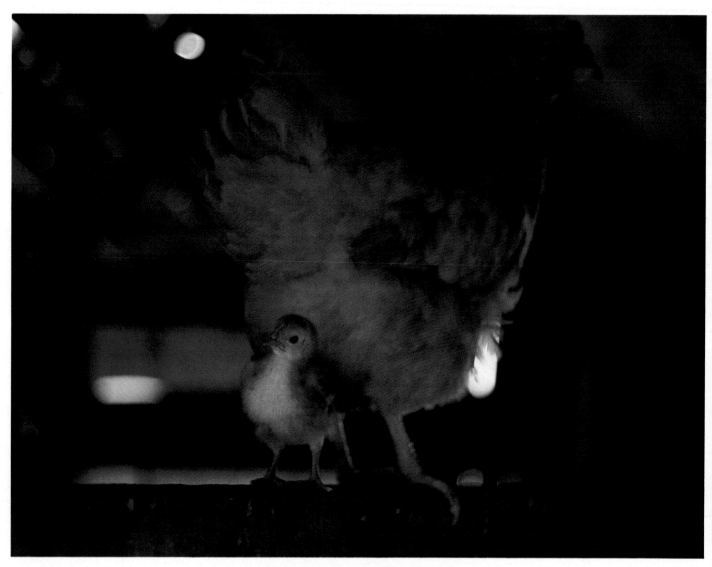

Under Her Wing: A mother hen and her chick.
Photo by the Rev. Sandra P. Haines of Owings Mills, Md.

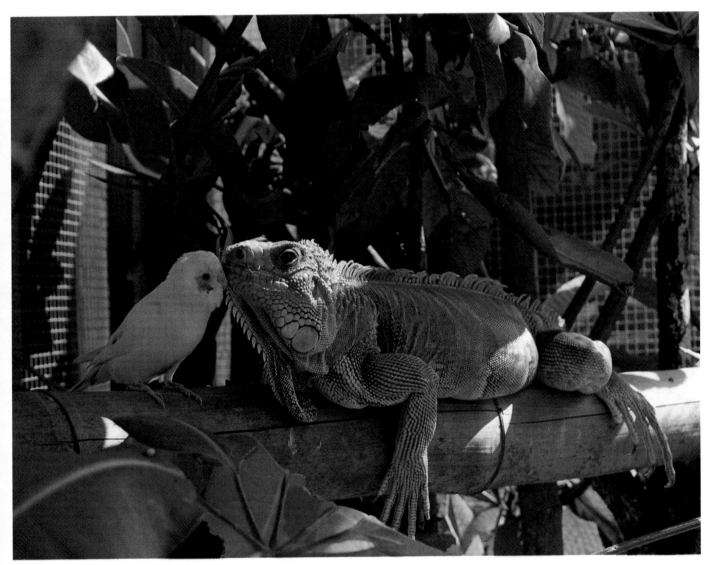

The Odd Couple: Godzilla, the iguana, and Love, the bird, have developed a nice rapport and even show a little affection from time to time. Photo by their owner, Marlies Justiz of Plantation, Fla.

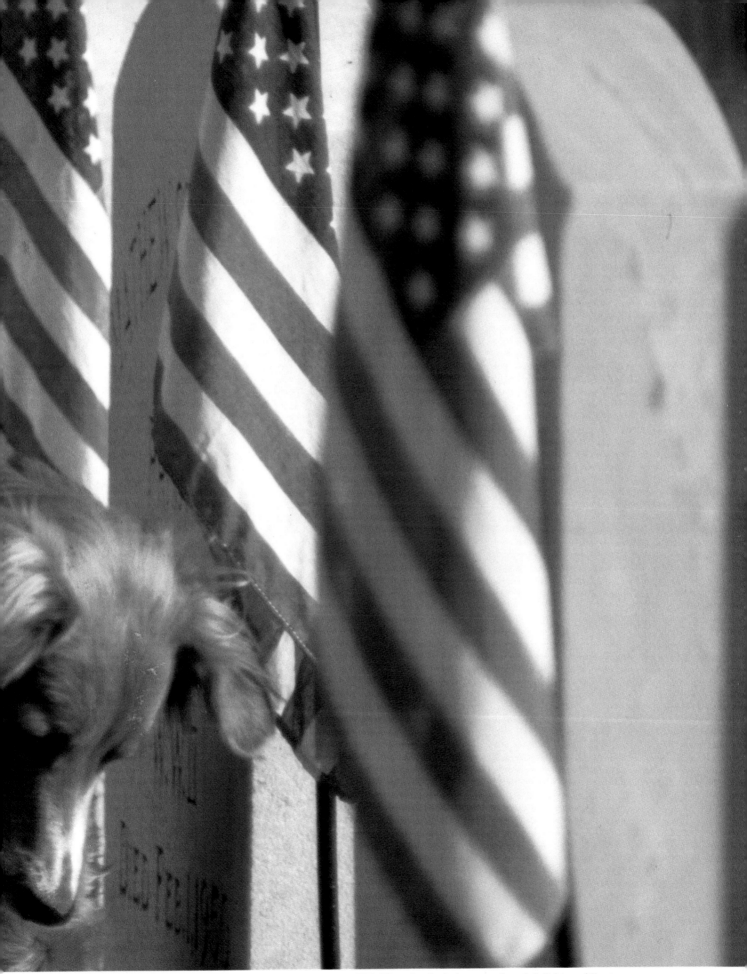

Corky Pays His Respects: A military gravesite in Trenton, N.J. Photo by Corky's owner, Joseph J. Tobias of Trenton.

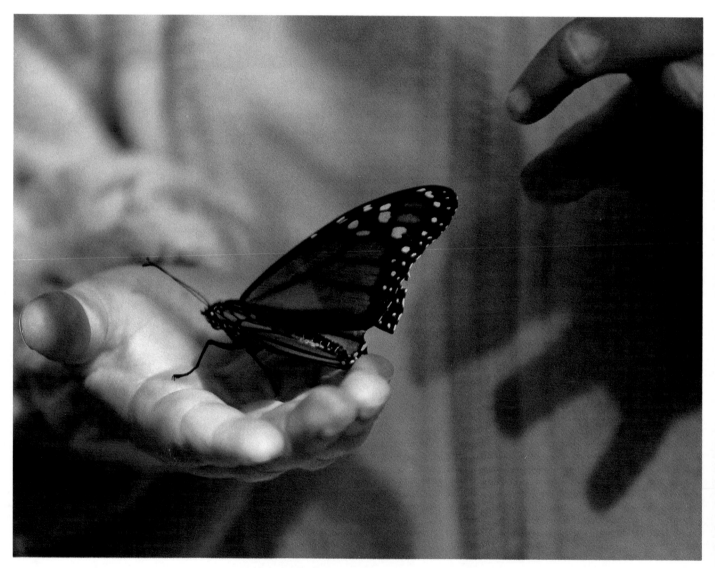

Gently Caught: Jessica Williams, 4, and fleeting friend at Natural Bridges State Beach, a Monarch butterfly preserve.
Photo by Janice Goff-LaFontaine of Capitola, Calif.

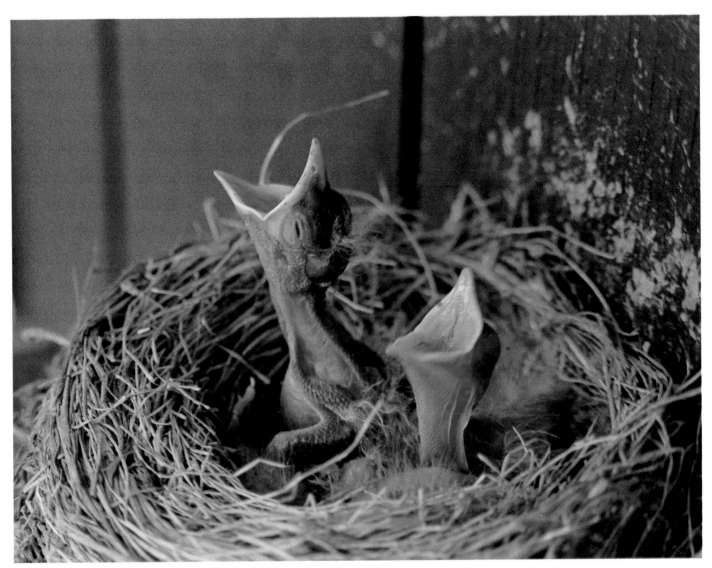

Love Some Breakfast: Two robin nestlings signal their concern only a few days after hatching.
Photo by John Rossbach of Flossmoor, Ill.

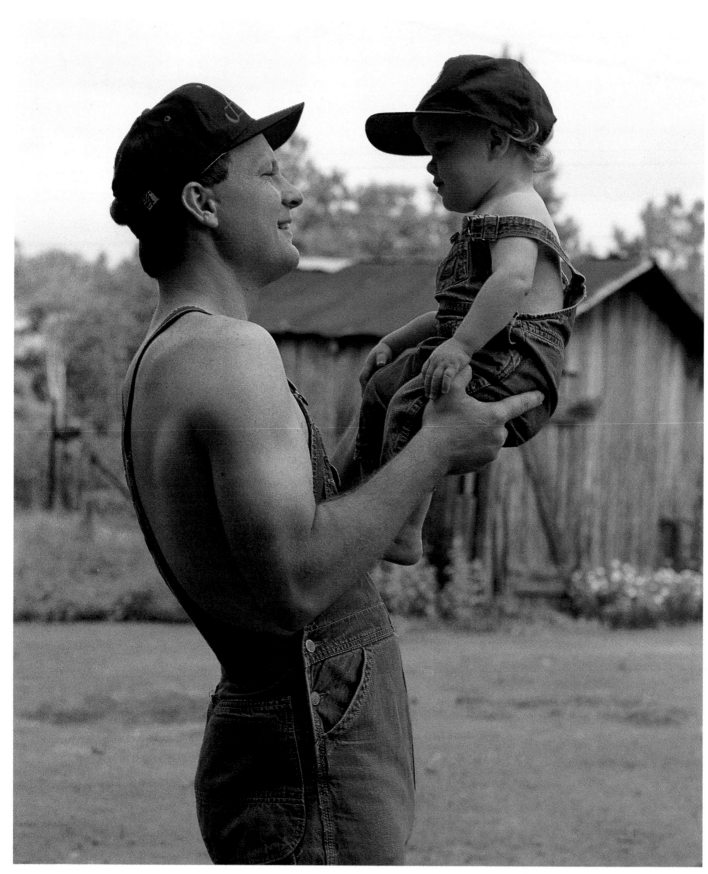

*Eye-to-Eye: Joshua Logan, 1, gets a big lift from his dad, Barry. Photo by
Joshua's mom, Ashley Logan of Birmingham, Ala.*

116

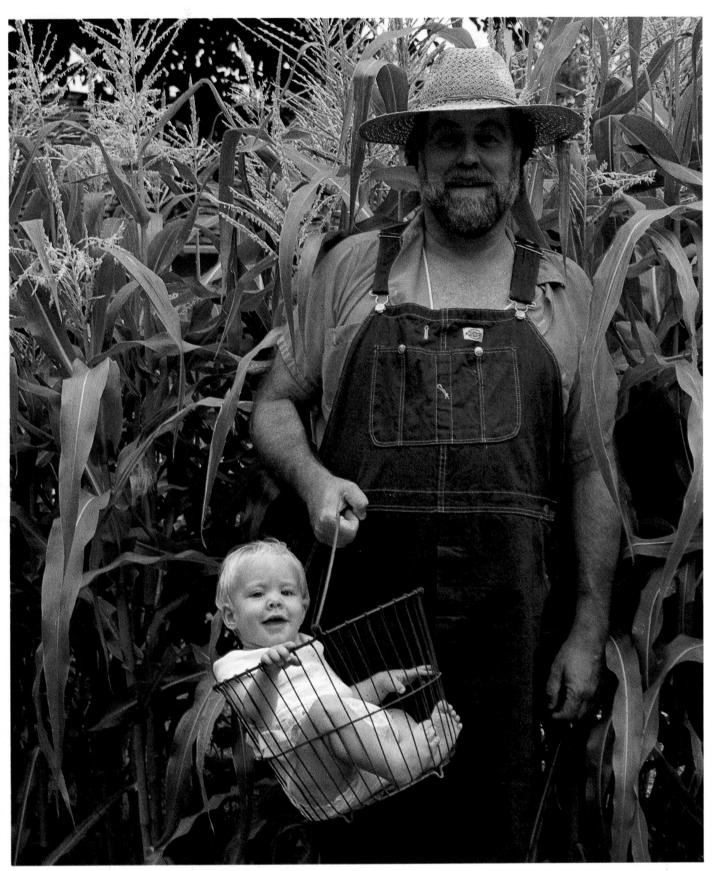

"What a Neat Way To Get Around!" Leslie G. Youngs and his daughter, Pepper Theresa, 2, set out to pick corn in the backyard of their home in Carmichael, Calif. Photo by Marguerite T. Youngs of Carmichael.

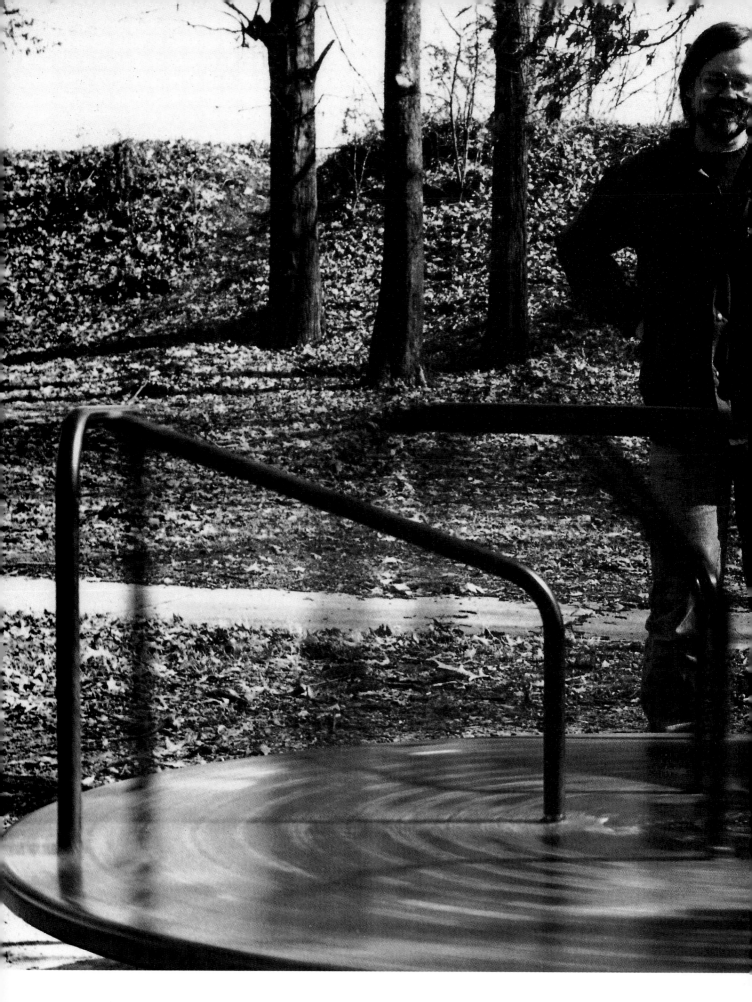

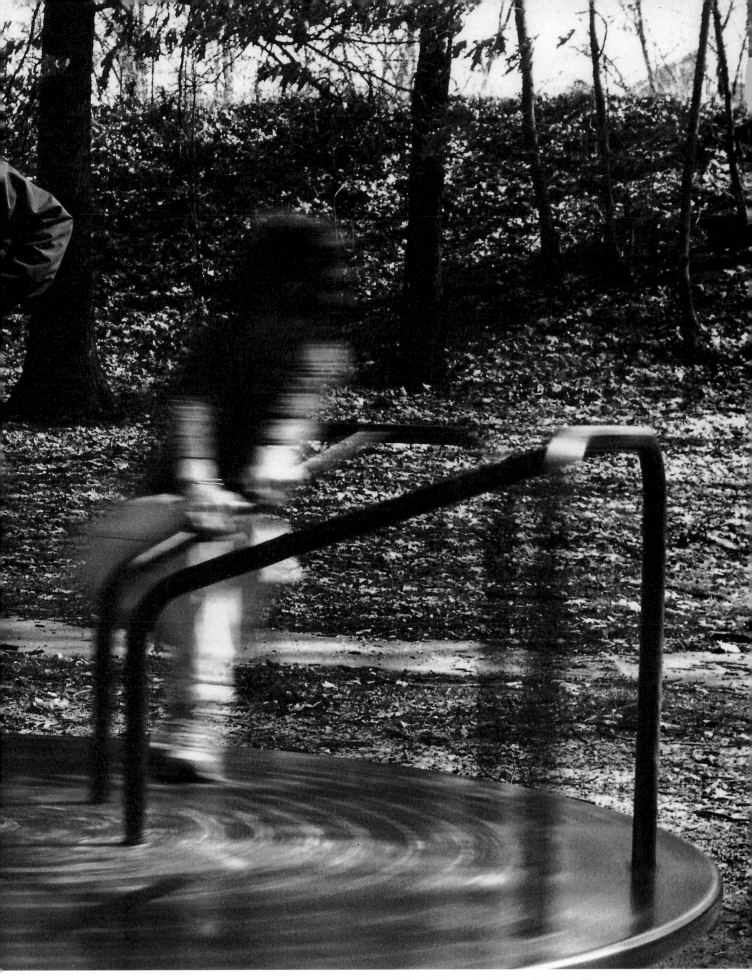

*A Whirlwind Romance? As Lois Knopp's husband, Wayne Simpkins, pushed, she held on.
The photo, by Lois Knopp of Memphis, Tenn., was taken with a time release.*

119

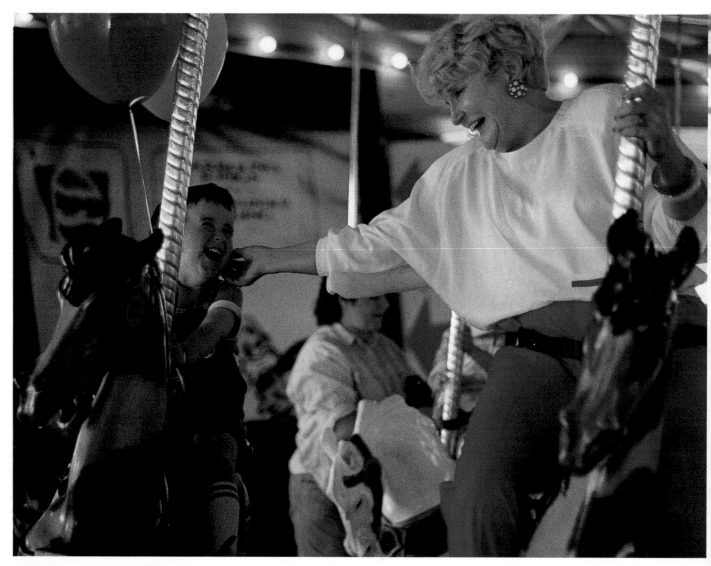

Shirley James and her grandnephew,
Matthew Westervelt, take a turn on
the merry-go-round in Spokane, Wash.
Photo by Shirley's husband, Richard
James of Evansville, Ind.

First-Time Fisherman:
Alfred Garrett, 5, gets a few pointers
from his grandfather, Chester Guess, 75,
of Oakland, Calif. Photo by Oscar
Williams of San Jose, Calif.

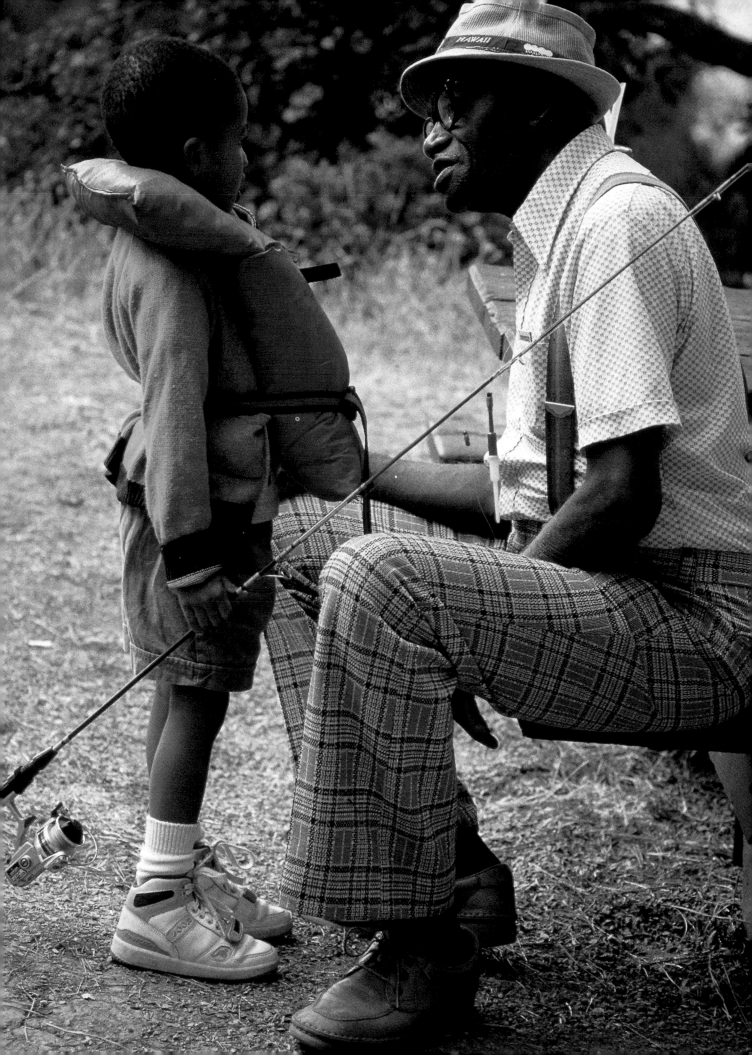

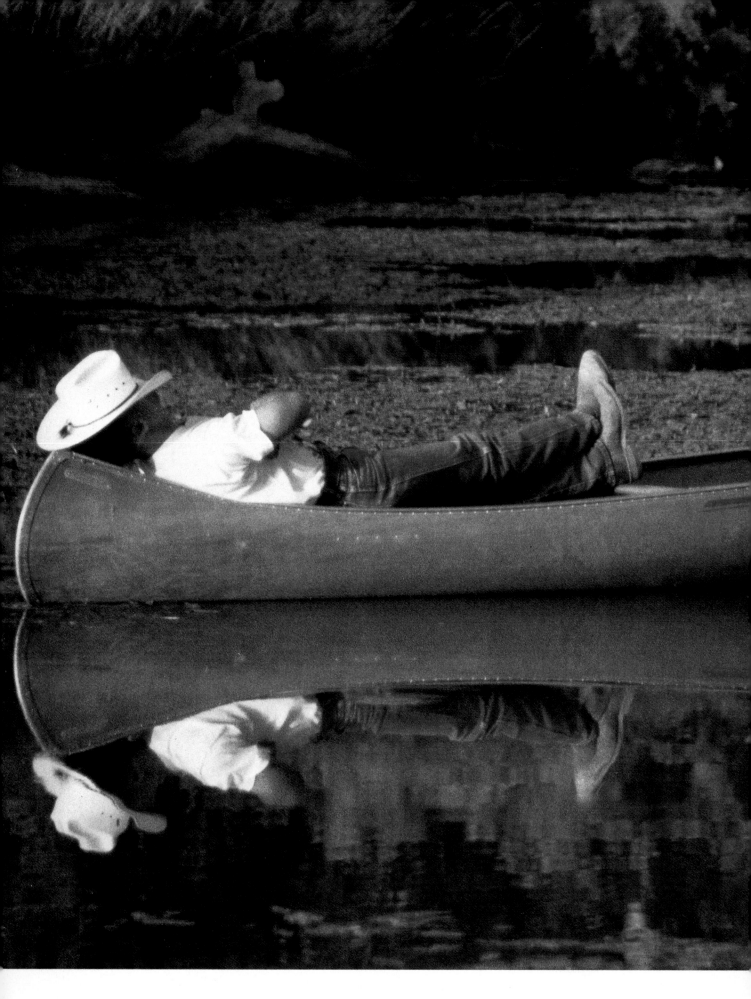

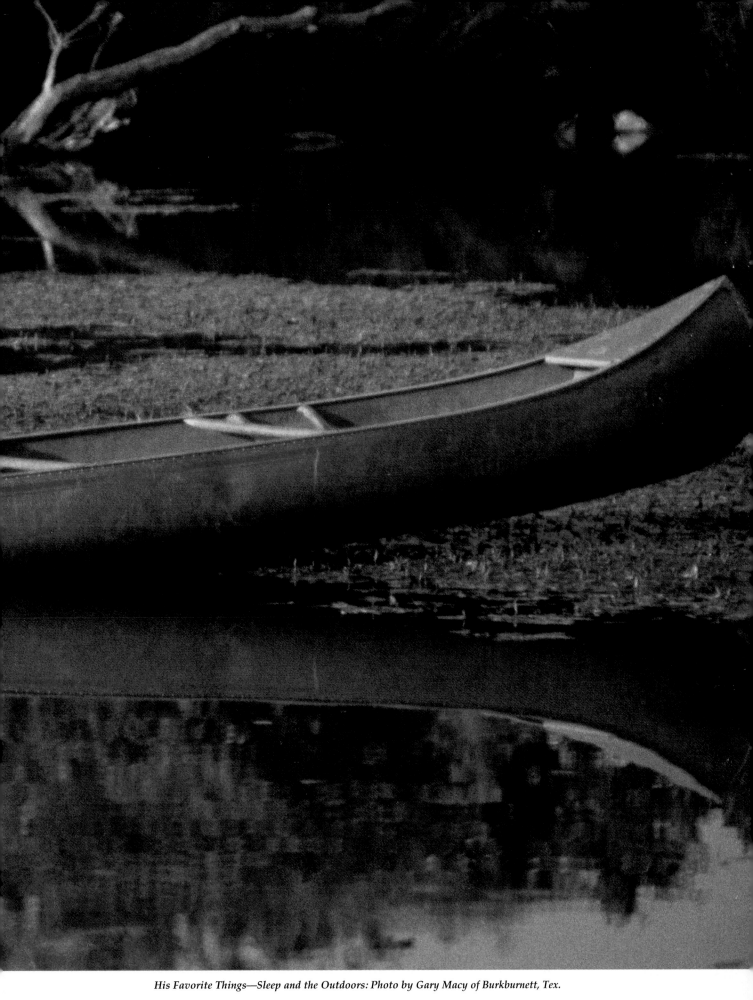

His Favorite Things—Sleep and the Outdoors: Photo by Gary Macy of Burkburnett, Tex.

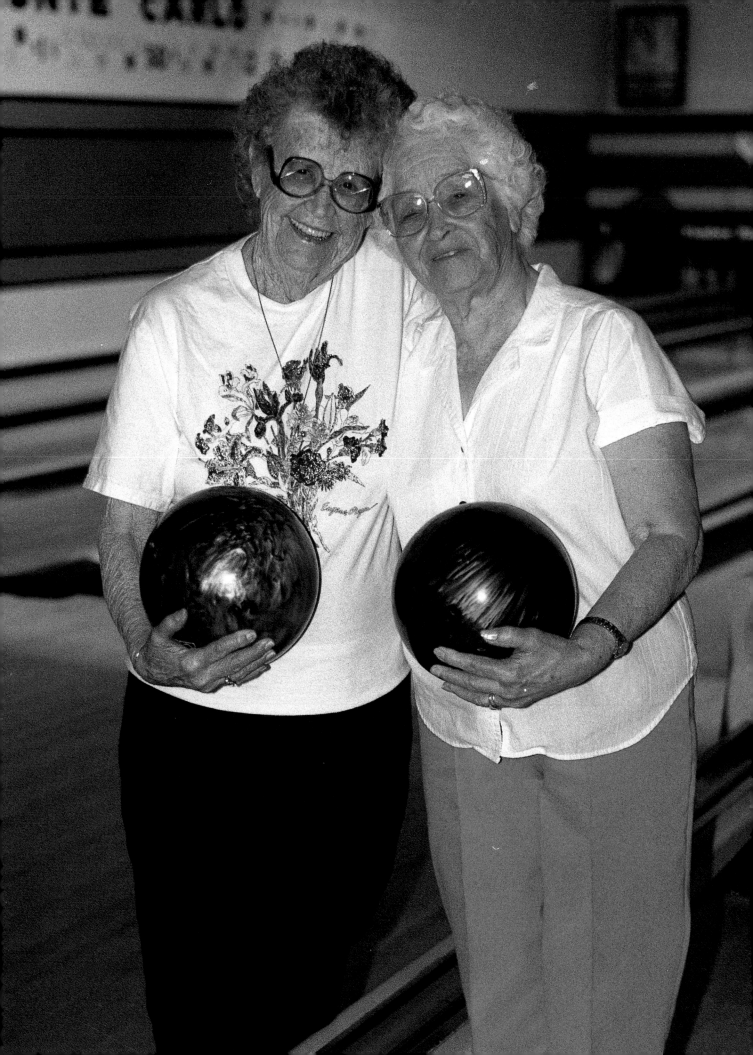

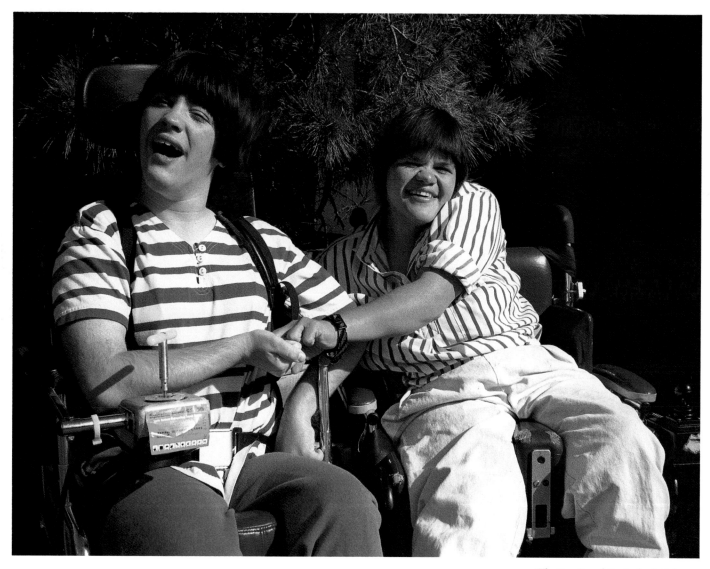

"That's a Laugh!": Amberly Johnson (l), 18, and Sylvia Villa, 24, enjoy a work break. Photo by Clairemarie Ghelardi of Santa Barbara, Calif., their instructor at Work Training Programs.

Alley Cats: Ellen Small (l) and Hallie Frey, both 81, of Springfield, Ore., bowl every week in the Granny's League. Photo by Sharon M. Thompson of Eugene, Ore.

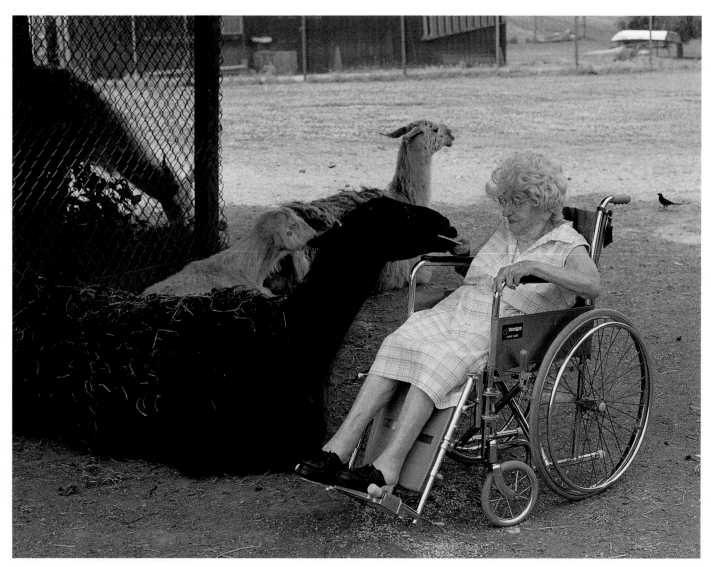

An Outing...and Memories: Anna Grabarits, 87, of Treichlers, Pa., who grew up on a farm, feeds llama at a game preserve.
The trip brought back great stories from her past, says her grandaughter, Carol Ann Ficek of Northampton, Pa., who took the photograph.

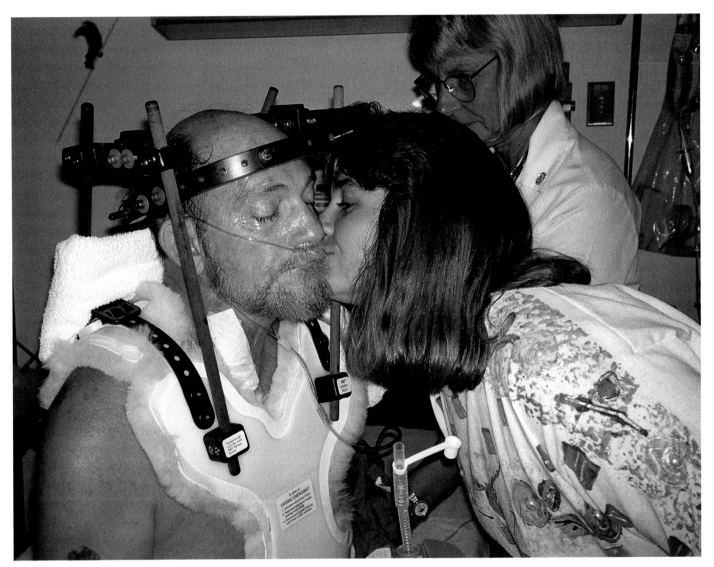

"Glad You're Okay." Hiram Collier, 55, of Fort Pierce, Fla., gets a kiss from his daughter, Tammy, 24, after undergoing extensive neck surgery. Photo by Hiram's wife, Lil Collier of Fort Pierce.

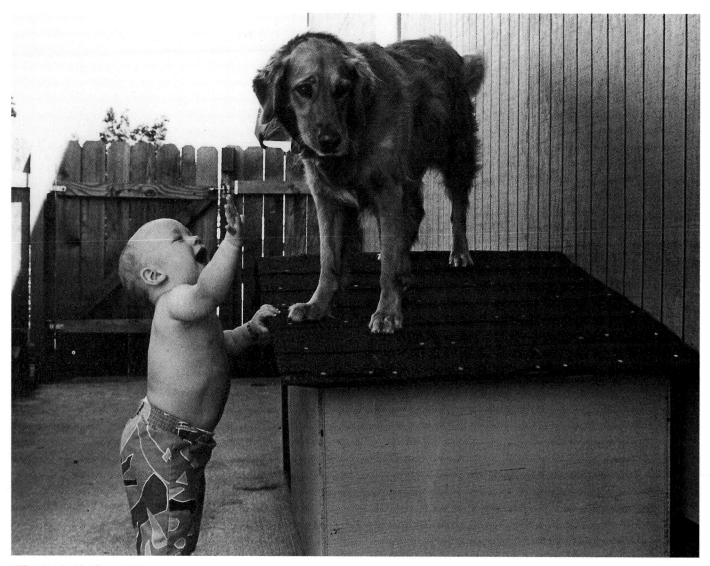

"Hey, You're Not Snoopy!"
It looks like Teal, 1, is telling Cassie
he'd be happier inside the dog house.
Photo by Teal's dad, Jeff T. Green of
Spokane, Wash.

Teaching With Love: Mary Ann Pasuit
with Spiros Tourloukis, 12, at Warren
Point School in Fair Lawn, N.J. Photo
by Marjorie A. Kuhn of Fairview, N.J.

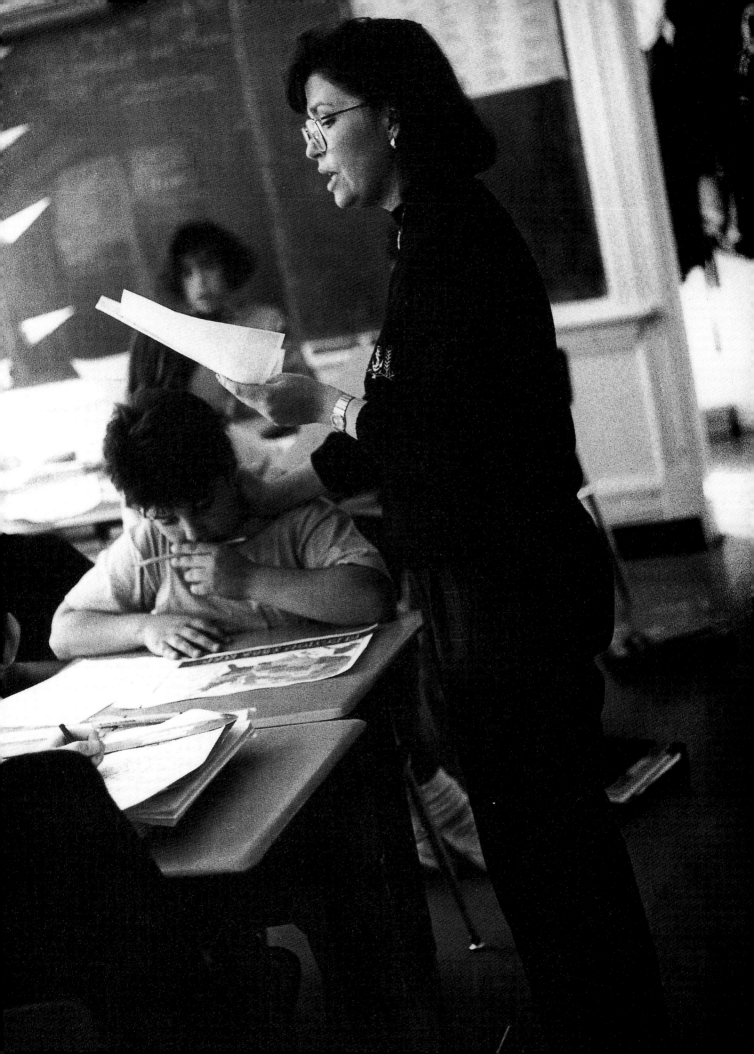

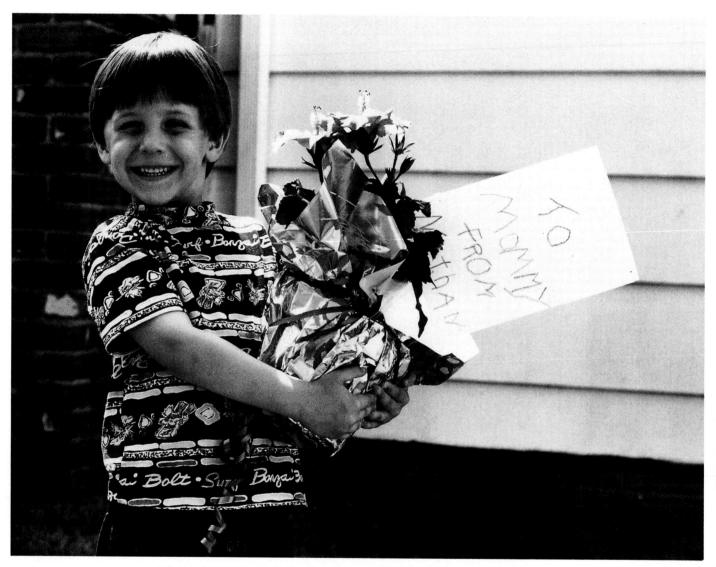

"Happy Mother's Day!" Nathan Harper, 5, presents his gift. Photo by his grandmother,
Billie J. Trahin of Baxter Springs, Kan.

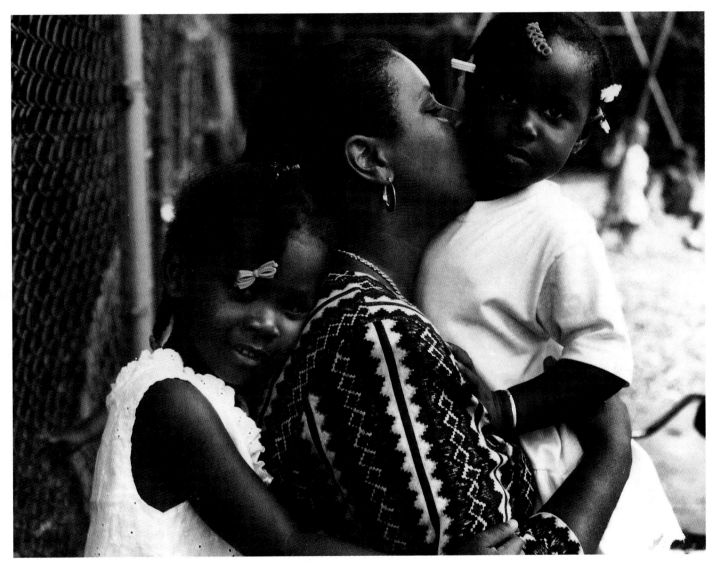

Embrace: Janet Elam, 28, a teacher at the Rose Marie Bryon Children's Center in Daytona Beach, Fla., with pupils Sheekerra Teal (r), and Mercedes Turner, both 6. Photo by Lee Ann Ropes of Daytona Beach.

"Life has taught us that love does not
consist in gazing at each other but in looking outward
in the same direction."
–Antoine de Saint-Exupéry

❧

"I love thee with the breath,
smiles, tears of all my life."
–Elizabeth Barrett Browning

❧

"The course of true love never did run smooth."
–William Shakespeare

❧

"Love conquers all."
–Virgil

*Welcome Home: He'd been gone for
half her lifetime, but Julie Frost, 2,
knew her daddy—U.S. Air Force Pilot
Robert Scott Frost—instantly
when he came home from Desert Storm
in May 1991. Photo by a friend, Julie
Needham of Bethesda, Md.*

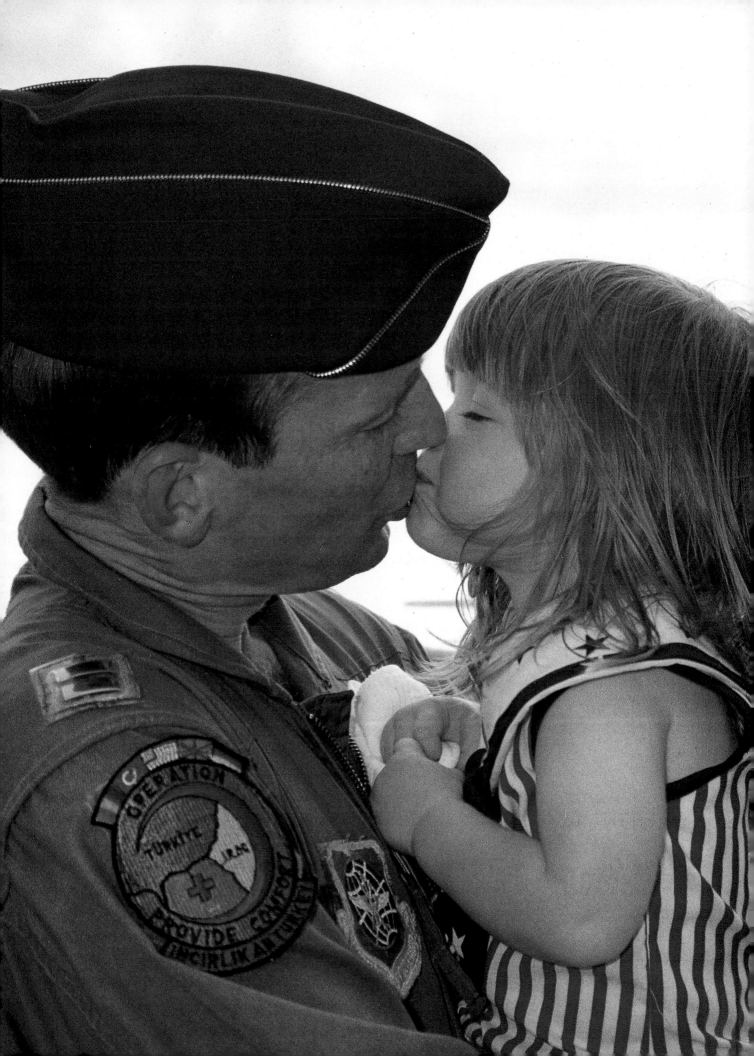

Big Feet, Little Feet: Lisa Fessenden, and her son, Joshua, 2, try each other on for size. Photo by Amy Fessenden of Richardson, Tex.

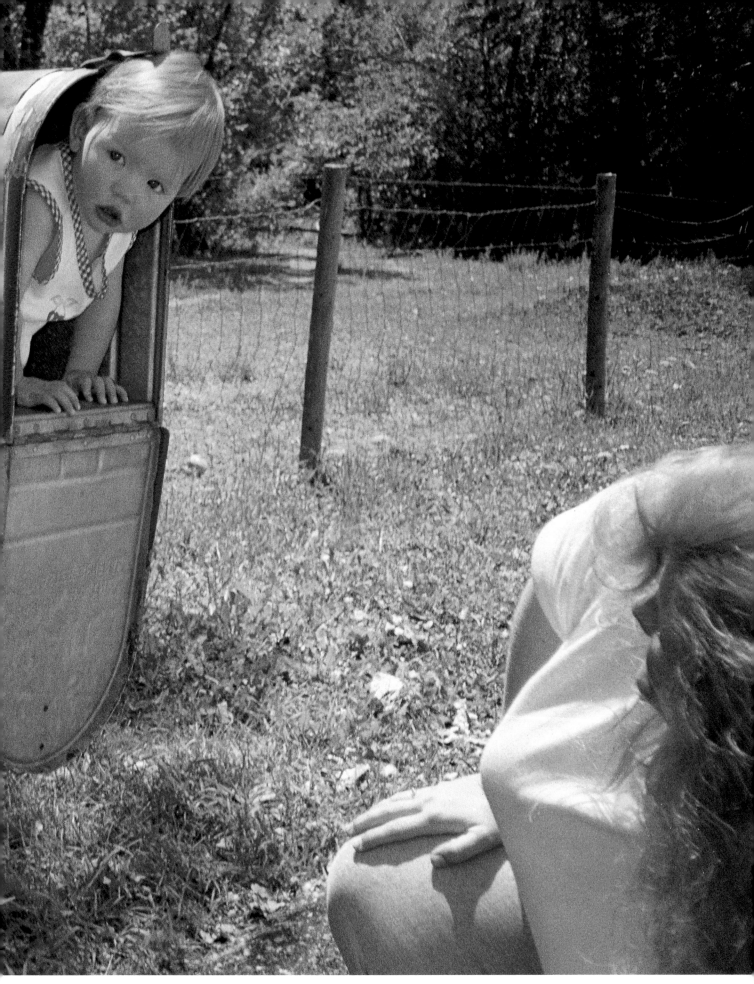

Special Delivery: Paige Rigot, 1, sends her dad a loving gift for Father's Day. Photo by Paige's mother, Cynthia Rigot of Denver, Colo.

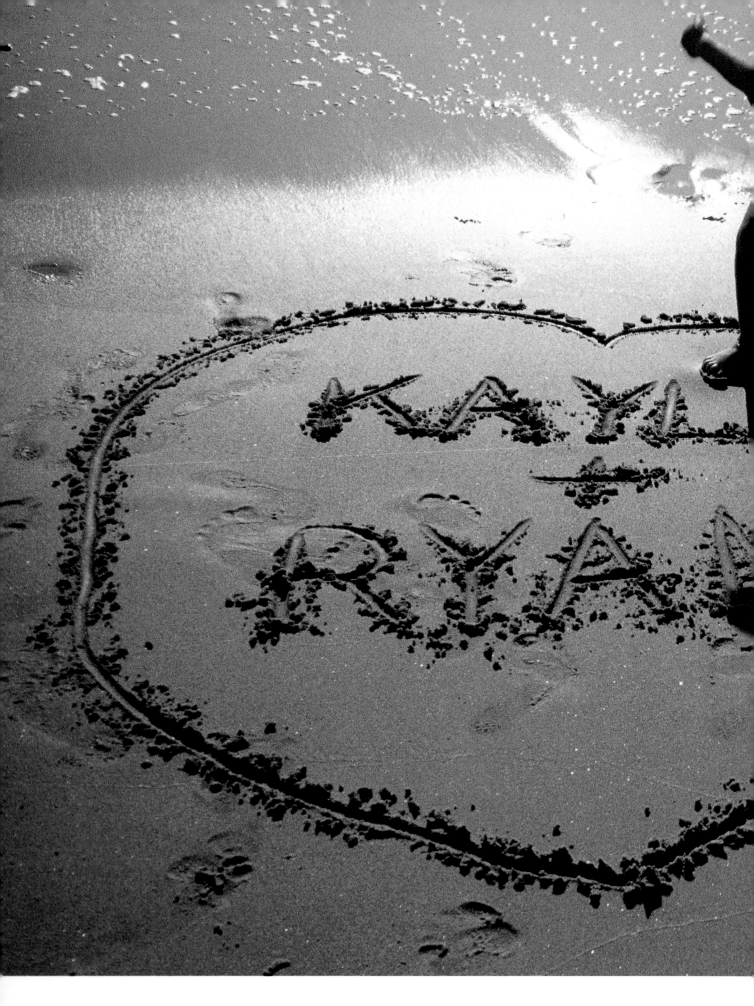

Love Letters in the Sand: Kayla Ernst, 4, shows how she feels about her little brother, Ryan, 1. Photo by Dorothy Stockley of Belleville, Ill.

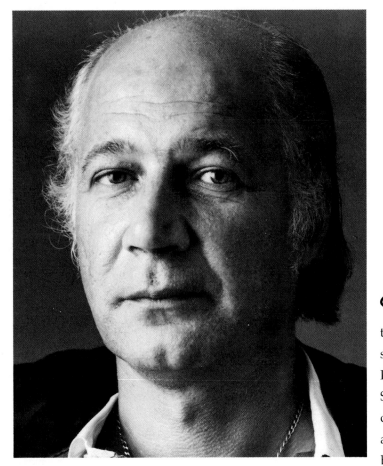

Eddie Adams

*L*ove. I can think think of no other concept which is as splendid or more baffling. From "Love Is a Many Spendored Thing" to "Love Stinks," this emotion has been the central subject of songs, movies, books and pictures. It is often the culprit behind our other emotions–happiness and deppression, anger, confusion and general angst. People go out of their way to look for it. Some fight for it, even kill for it and die for it. Although it's a very personal emotion–I don't think any two people would describe it in quite the same way–it is also one that everyone, I think it's safe to say, desires most.

A good photographer tries to capture emotion in his photographs, and trying to record "Love" on film is something unique, because, as I mentioned, it encompasses all other emotions. And in this day and age, with all the wonderful technological advances which allow us to pay less attention to the camera and more to our subjects, anyone can get the perfect shot.

The photos in this book are a great representation of the contest theme. In my past seven years as a judge, I don't think I've ever seen so many entries pour into the PARADE offices. And though it's not surprising, it was good to know that more than 200,000 people wanted to show their expressions of love to the rest of the country.

It was a great thrill to judge this contest. It appealed to the voyeur in me–I got to take a peek into other people's love lives, and so can you! Just sit back, put your feet up, flip through the pages of this book and share in the love!

Love, Eddie

ove–the theme of this collection of photos–is defined here in images, not words, with which I try to define it–unsuccessfully. Love is...so many wonderful things.

How many love poems and songs strive to explain what love is? How many words have been devoted to the subject? How many times have we tried to tell others about the love that we feel for them? About how much their love for us means to us? How often do our words fail us?

"Words, words, words, I'm so sick of words!" shouts an exasperated Eliza Doolittle in the musical *My Fair Lady*. "Don't talk of love," she exhorts– "Show me!"

This book of prize-winning photographs attempts just that–to *show you*.

A picture is said to be worth a thousand words, and these 100 pictures were chosen with much thought and feeling and were found to be the best of the 233,400 sent to us by PARADE readers across the country eager to have their lenses speak to us of love. It was not always easy to choose– but these etched themselves into our hearts. We offer them–instead of 100,000 words–to you, confident of the clarity of the love they convey, as it spans all ages, circumstances and relationships.

These pictures show us little ones, looking forward, reaching out, taking, giving and inspiring love from those around them. They show the elderly, rich with years and lessons learned, trials endured, love given, harvested and growing anew. They show youngsters trusting others of their own age and older, and nurturing those who are even smaller and more vulnerable. And they show adolescents trusting themselves to dare to try new adventures in the lives they've come to love. There are pups and possums and lambs–creatures great and small that walk, fly, swim and populate our world, enriching our lives, evoking our love.

The two siblings at play in the garden-hose spray show the enchantment of youth and their brother–sister love for one another and for the many joys they find in a single golden summer's day. Each photo in some way records love and depicts ways in which it enriches us all. There's no sales tag on love: It's priceless. You can't buy it, but you can find it, if you know where to look. Proudly, we present these photos and say: Look here!

Dr. Joyce Brothers

Marian Wright Edelman

\mathcal{W}hen people hear the word "love" they may think of time spent with a special someone or think, as the old song goes, of marriage. Romance certainly features in these prize-winning photographs. In fact, the song's lyrics are well represented, right down to the newlyweds and the horses–though I'm afraid that nobody felt the emotion for a carriage. Motorcycles will have to do.

Yet, romantic love is the subject of only a few of these photographs. Flip to any page. More likely than not, you will see a child. As founder and president of the Children's Defense Fund, I was overjoyed to find that so many entrants saw love in the faces of America's children. Many of these children are pictured in the arms of an adult, while others simply enjoy a close moment with a friend, a sibling or even a prize sheep.

As I viewed these photographs, I was especially moved by the pictures of children enjoying everyday activities. A father and son slathered with shaving cream; two kids cooling off in a sprinkler; two more toddling down a garden path–can you pinpoint the love in these images? The happiest answer may be that you cannot. For each photograph of these children is a parent, grandparent or friend who stood behind the camera. Isn't the photographer's invisible love for the subject as much a part of the picture as the image caught on film? And the best part is, though the pictures will remain frozen in time, the love of family and friends will stay with the children and help them become confident, loving adults.

"\mathcal{L}ove"–What is this emotion that has inspired great works of art, literature and music? How, indeed, can you depict the spirit of "Love" in a photograph, capturing an essence which is at once universal yet intensely personal?

I asked myself these questions as a first-time judge of the PARADE-Eastman Kodak "Love" Photography Contest. As I sifted through some of the more than 200,000 entries to select the 100 winning photos displayed in this book, I was struck by the eloquence and skill used to illustrate the theme.

Each photo, in its depiction of romantic love, family love, the camaraderie of friends, or simple acts of human kindness, had a common thread–no one was alone. Each photo showed in its way that "Love" is not a solitary pursuit. While it may be portrayed by the newlyweds sharing a quiet embrace, the Arabian mare nuzzling her foal, the child drawing a heart with his beloved's name in the sand or the hand that tenderly feeds an aged person, what comes across clearly is the comfort of "Love."

At a time when we are all too often besieged by a world beset with violence and turmoil, take a moment to celebrate the sweet, simple side of life. Let these splendid photographs touch your heart and inspire you to believe that the power of "Love" can heal the soul and nourish the spirit, renewing and strengthening us so we may stand fast in the face of whatever life brings our way.

Leeza Gibbons

Casey Kasem

\mathcal{L}ooking at these pictures about love made me think about my radio show and a segment called "Dedications." Every week, I read a letter on the air from a listener who explains the message he/she wants to convey to someone through a song. Some of the letters are quite poignant because listeners use them to ask for forgiveness, or to say "I love you" or "I miss you".

These dedications are similar to the pictures you will see in this book since each photograph also sends a message. Some of the pictures that I chose represent love of family which is important to me, especially since I have a wife and four children. Take, for example, the picture of a mother and daughter enjoying a day of beauty as they share a guacamole facial; a mother possum taking her children for a walk as they sit on top of her back or the picture of four young girls combing each other's hair.

As you look at each photograph, one may remind you of a family member, a pet, or a relative and some happy event that you shared. Although these pictures depict ordinary events, I'm certain you'll enjoy them just as much as I did because of their recurrent message about love.